The Campus History Series

VIRGINIA
COMMONWEALTH
UNIVERSITY

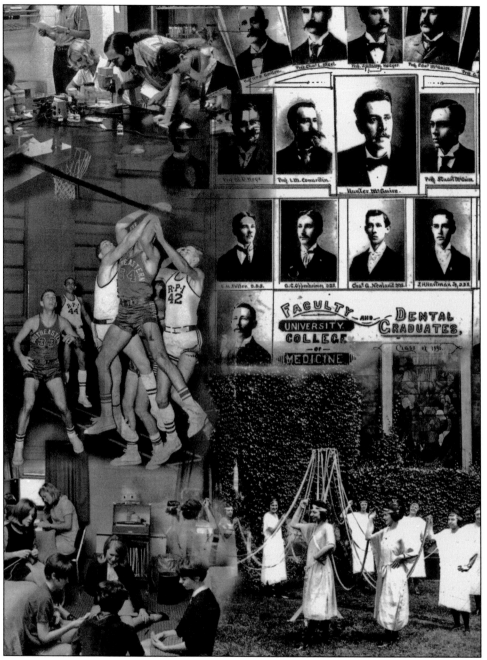

VCU HISTORY COLLAGE, 1997. Clockwise from upper left are the 1970s School of Medicine lab, the 1896 faculty and dental graduates of the University College of Medicine, the *c*. 1930 May Day festivities at which a May queen was elected, a *c*. 1970 dorm room, and a 1962 RPI basketball game in the Franklin Street Gym.

ON THE COVER: **RICHMOND SCHOOL OF SOCIAL WORK STUDENTS, 1917.** Henry Hibbs and the student body pose in Capitol Square in front of the monument to Hunter H. McGuire, former professor of surgery at the Medical College of Virginia.

The Campus History Series

VIRGINIA COMMONWEALTH UNIVERSITY

RAY BONIS, JODI KOSTE, AND CURTIS LYONS

ARCADIA
PUBLISHING

Published by Arcadia Publishing
Charleston, South Carolina

Printed in the United States of America

Library of Congress Catalog Card Number: 2005938621

For all general information contact Arcadia Publishing at:
Telephone 843-853-2070
Fax 843-853-0044
E-mail sales@arcadiapublishing.com
For customer service and orders:
Toll-Free 1-888-313-2665

Visit us on the Internet at www.arcadiapublishing.com

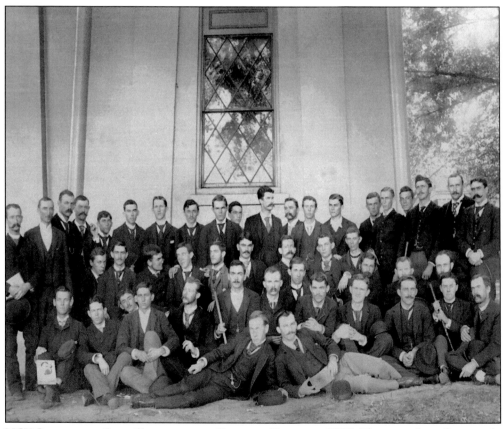

MCV GRADUATING CLASS OUTSIDE OF THE EGYPTIAN BUILDING, 1882. Photographers frequently selected the Egyptian Building as a backdrop for class and staff photographs at the Medical College of Virginia. This practice, begun in the late 1860s, continues to be popular today among those who work and study on the MCV Campus of Virginia Commonwealth University.

CONTENTS

Acknowledgments 6

Introduction 7

1. A Medical School in the Capital City: 1838–1865 9

2. Rivals and Reform: 1866–1924 17

3. Building an Academic Medical Center: 1925–1968 31

4. The Genesis of a Professional School: 1917–1944 45

5. An Entirely Different College: 1945–1968 61

6. Creating a University: 1968–1978 75

7. Virginia's Urban University: 1978–1990 95

8. Eugene P. Trani and the Expansion of VCU: 1990–2005 113

ACKNOWLEDGMENTS

The authors are indebted to those who diligently kept the university's history over the last 168 years. A special thanks is extended to the staff members at both campus library archives who over the years helped with the collecting of university photographs, publications, and archives.

The authors extend their thanks to the following individuals: Kathryn Korfonta of Arcadia Publishing; Charles Saunders of the *Richmond Times-Dispatch* archives; Sarah Hand of the VCU Planning and Design Department; Justin Harris of the VCU Athletic Department; Dale L. Neighbors of the Library of Virginia; Linda George and Patti Ferguson of VCU Creative Services; graphic artist Christopher Hibben; and photographers Jeff Crossan, Ken Hopson, and Jay Paul.

We appreciate the support of VCU Libraries and the university administration. We also want to thank our family and friends who have been so patient with us throughout the process.

All images not attributed in captions are from Special Collections and Archives of the VCU Libraries.

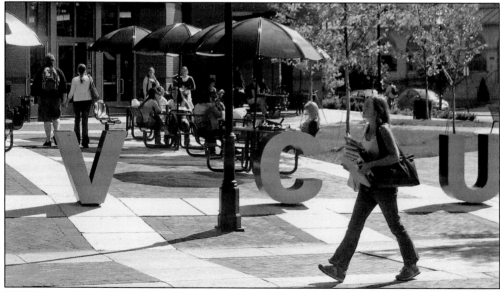

VCU DINING HALL, 2005. A student passes the yellow letters of VCU in front of the award-winning, $18-million Shafer Dining Center. (Image courtesy of Ken Hopson.)

INTRODUCTION

The story of Virginia Commonwealth University (VCU) begins with the formation of the Medical Department of Hampden-Sydney College in Richmond in 1838. Four physicians led by Augustus L. Warner took advantage of the opportunities for clinical instruction in the developing city while stemming the tide of Virginians heading north for medical education. The Virginia General Assembly granted the school an independent charter in 1854 and named it the Medical College of Virginia (MCV). The college became a state institution in 1860. During the Civil War, MCV remained open and played a vital role in educating physicians and caring for the sick and wounded.

MCV struggled in the years following the Civil War. Poor finances, outdated teaching methods, and antiquated facilities spiraled the institution into decline. A rival school was formed in 1893 that finally forced MCV to make changes, including the organization of separate schools of dentistry, nursing, and pharmacy. The merger of MCV and the University College of Medicine finally laid the foundation for medical education in the 20th century. During World War I, MCV opened its doors to women.

In 1925, MCV selected William T. Sanger to be the first full-time president. He hired the first full-time faculty at the medical school, built an impressive physical plant, and expanded the educational programs during his 31-year tenure. MCV made a major contribution during World War II by staffing the 45th General Hospital in Europe and North Africa and by accelerating the instructional program to respond to the need for additional trained health care professionals. MCV continued to grow during the late 1950s under the presidency of Robert Blackwell Smith Jr. The college expanded graduate education, secured accreditation by the Southern Association of Colleges and Schools, and increasingly engaged in clinical and scientific research.

The Richmond School of Social Economy was designed to address a host of social, economic, and health issues. Henry H. Hibbs Jr. began the school on a shoestring budget in a facility provided by the city and immediately began supplying free labor in the form of student field work. After existing in three leased locations and undergoing two name changes, the school purchased what became known as Founder's Hall and affiliated with the College of William and Mary in 1925. The school was renamed the Richmond Professional Institute of the College of William and Mary (RPI) in 1939 in order to denote the unique character of the institution.

The influx of hundreds of thousands of veterans armed with the G.I. Bill revolutionized every college campus in the United States in the period following World War II. RPI's ability to stretch to accommodate the wave of G.I.'s did not go unnoticed. As demographers began registering the seismic signals from the baby boom, the state realized that it needed to expand its educational infrastructure and began allocating money to RPI to help alleviate the anticipated shortfall.

When George Oliver took over as president in 1959, he did not believe that RPI still needed the name recognition that William and Mary brought. This coincided with a growing radicalism among the students and faculty of RPI that began a movement to sever the relationship with the parent school. Richmond Professional Institute became an independent state university for the first time in 1962.

By the late 1960s, elements of the Virginia state government and the boards of both RPI and MCV had conducted innumerable meetings, convened several commissions, and introduced legislation to combine the two schools that served as bookends for downtown Richmond. MCV and RPI merged in 1968 to form Virginia Commonwealth University, setting off a period of unprecedented growth and change. The long processes required to incorporate two administrations, faculties, student bodies, facilities, policies, and traditions took well over a decade to come to fruition.

This was the primary focus of VCU's first three presidents. By the time Edmund F. Ackell became president in 1978, the paperwork had been done and the titles changed, but the university was far from united. Ackell continued to focus efforts internally. He constructed new dormitory and parking facilities to bring students together physically, but the construction could not keep pace with enrollment increases. Efforts to build a stronger athletic program led to an extremely strong period in Rams basketball through the mid-1980s, but the school spirit generated never spread past athletics to excite the student body about the university as a whole.

Eugene P. Trani took a different approach when he was named president in 1990. He initiated a transformation of the university that included a focus on integrating VCU both economically and socially with the community. First the university established significant relationships with the business sector. This enabled key initiatives such as the VCU School of Engineering and the Virginia Biotech Research Park to come into existence. Second the university established formal partnerships with neighboring communities, the first of such efforts in the city. During this time, university-wide academic initiatives such as life sciences, which brought faculty and students from the two campuses together, generated a growing sense of pride in the university as one entity.

A major theme in the history of these three institutions is the relationship between what a public, urban research university can provide and what a major metropolitan area needs. Virginia Commonwealth University and its predecessors have fueled Richmond's economy by educating its workforce, spurring development, and securing federal and state research funds. It has provided medical assistance in every form to Richmond's citizens through three major wars and every public health crisis of the 20th century. It has contributed to the city's social consciousness and cultural life and offered solutions to many of its urban problems in the form of both ideas and alumni. From its clinical instruction program in the 19th century to social work in the early 20th century to life sciences in the 1990s, it has been on the cutting edge, offering innovative programs designed to directly benefit its constituency: the people of the region and state.

One

A MEDICAL SCHOOL
IN THE CAPITAL CITY
1838–1865

MCV 1860
State
institution
launched

Richmond, the capital of Virginia, was a city of developing commercial, manufacturing, and industrial interests when four local physicians proposed to organize a medical school in 1837. Antebellum Americans opened medical schools at a record pace in order to meet the needs of an expanding population. Dr. Augustus L. Warner and his three associates believed Richmond's slaves, free blacks, and laborers would provide the necessary "clinical material" to support medical instruction. They petitioned Hampden-Sydney College, which agreed in December 1837 to start a medical department under their auspices. The first students enrolled in November 1838.

By 1844, the Medical Department had moved to its own building, graduated five classes, and developed a reputation for operating independently from its parent institution. The department dissolved its connection with Hampden-Sydney in 1853 following a dispute over a faculty appointment. The Richmond physicians secured a charter from the Virginia General Assembly in 1854, thereby creating the Medical College of Virginia (MCV). The college needed additional clinical facilities and secured a loan from the legislature in 1860 to support the construction of a hospital. In return, MCV conveyed all of its property to the Commonwealth of Virginia, making it a state institution.

The Civil War soon intervened. MCV played a major role during the conflict by educating Confederate surgeons and caring for the sick and wounded. The school operated continuously, graduating a class each year of the war, one of only three Southern medical schools to do so and the only one still in existence.

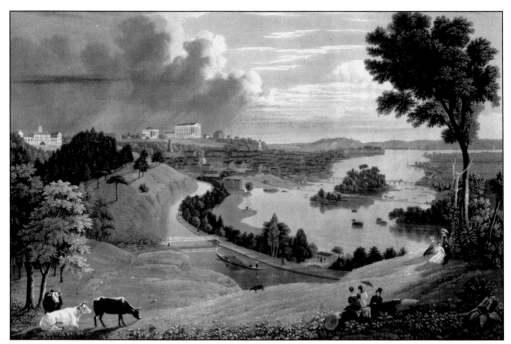

RICHMOND, VIRGINIA, FROM THE HILL ABOVE THE WATERWORKS BY GEORGE COOKE, **1834.** Richmond, around the time of the founding of the Medical Department of Hampden-Sydney College, was a city of 20,000 inhabitants including 8,000 slaves fueling the milling, tobacco, and emerging iron industry. (Courtesy of the Library of Virginia.)

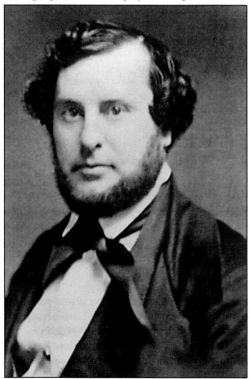

AUGUSTUS L. WARNER, DAGUERREOTYPE, **1840s.** Warner (1807–1847), born and educated in Baltimore, left the University of Virginia because he found the conditions unsuitable for medical instruction. Moving to Richmond in 1837, he led the physicians who organized the Medical Department of Hampden-Sydney College. As both professor of surgery and dean, Warner guided the fledgling department during its formative years until his early death.

UNION HOTEL, 1890. The first home of the Medical Department, located at the corner of Nineteenth and Main Streets, was an old hotel converted into an infirmary and a series of lecture halls. The infirmary, a major selling point for the new medical department, provided students an opportunity to observe surgical operations firsthand as well as study the "diseases incident to a Southern climate."

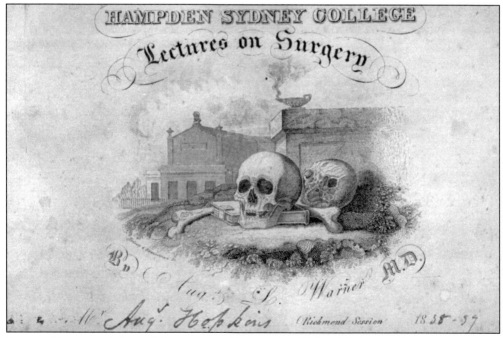

LECTURE TICKET FOR WARNER'S LECTURES ON SURGERY, 1838–1839. Nineteenth-century students purchased tickets to attend medical lectures as a form of tuition. These tickets served as proof of payment and gained the student admittance to the lecture hall. Tickets at the Medical Department cost $20 a course. Faculty members earned $500 to $1,000 from the sale of lecture tickets each session on top of their income from private practice, consulting, and other activities.

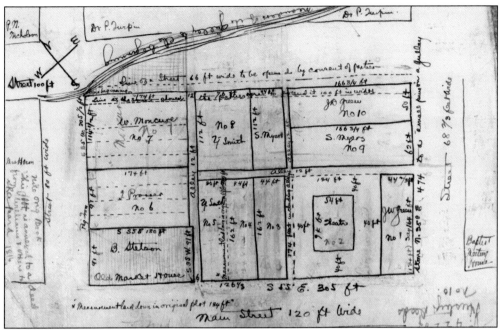

MAP OF ACADEMY SQUARE BY ADÈLE CLARK, 1930s. By the early 1840s, the Medical Department had outgrown its quarters at the Union Hotel. The City of Richmond donated $2,000 to the faculty for the purchase of property on Marshall and College Streets within Academy Square, the site of a failed arts and sciences academy. The Virginia Convention met in the academy building in 1788 to ratify the U.S. Constitution.

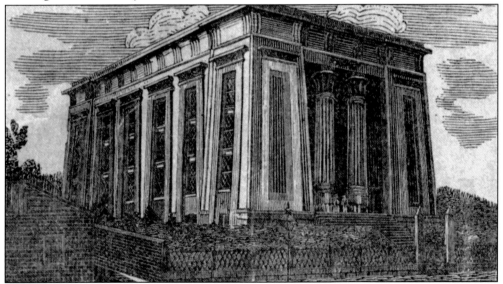

ENGRAVING OF THE EGYPTIAN BUILDING, 1854. Warner worked closely with architect Thomas Stewart (1806–1889) of Philadelphia in designing a new home for the Medical Department. This Egyptian Revival–style building opened in the fall of 1844 and featured three lecture halls, a large dissecting room, and an infirmary. Loans from the state's literary fund financed construction, and each faculty member was assessed semi-annually to cover the six-percent interest payments.

12

Egyptian building the new Medical Dept
after the union hotel. 1854

CHARLES EDOUARD BROWN-SÉQUARD, *C.* 1855. Brown-Séquard (1817–1894) arrived at the newly christened Medical College of Virginia in the fall of 1854. The French physician undertook a number of research experiments during his one year as professor of medicine and medical jurisprudence. Vocal in his disapproval of slavery, Brown-Séquard never felt comfortable in Richmond and left for Paris, where he subsequently achieved great renown for work in physiology.

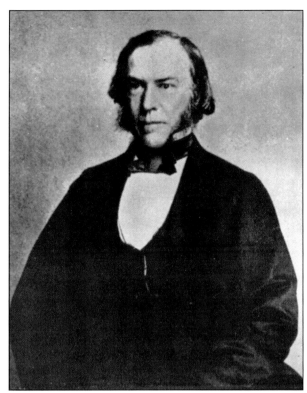

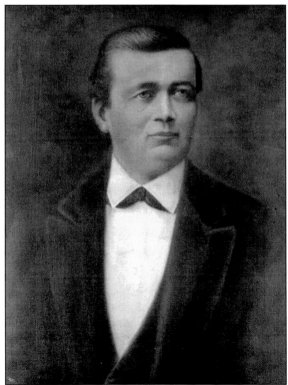

EMMETT A. DREWRY, 1860s. Philadelphia medical institutions attracted Virginians in record numbers in the years before the Civil War. Following John Brown's hanging in 1859, Philadelphia became a hostile city for Southerners. A group of medical students including Emmett Drewry "seceded" from their Northern schools and matriculated at MCV, tripling enrollment overnight. For the next five years, Virginians stayed at home for their medical education.

13

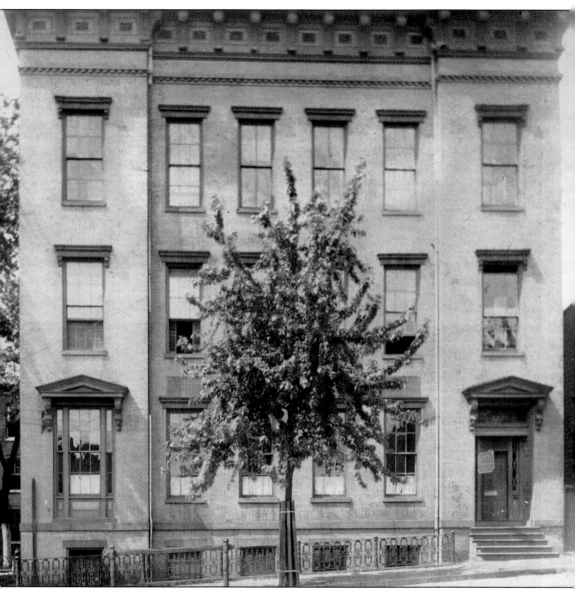

COLLEGE HOSPITAL, 1890s. The growing medical college needed additional space and sought funding from the legislature for the construction of a modern hospital. In 1860, the Virginia General Assembly appropriated $30,000 towards the cost of this clinical facility, and the college conveyed all of its real property to the state in return. The Board of Visitors noted, "The Medical College of Virginia is now not merely under the patronage of the State, but under its absolute ownership and control." The three-story brick hospital, located adjacent to the Egyptian Building on Marshall Street, was constructed at a cost of $22,336.57 and featured gas lights, heat, and a large surgical amphitheater where students could observe operations firsthand. The 80-bed facility opened in April 1861 as the Civil War erupted. The building served the college in a variety of capacities over the next 50 years. It was renovated and reopened as the Old Dominion Hospital in 1893 and continued as MCV's clinical teaching facility for the next decade. The building was ultimately razed in 1917 to make way for the St. Philip Hospital.

14

LEVIN SMITH JOYNES, 1860s. Joynes (1819–1881), a native of Accomack County, served as dean and professor of medicine and medical jurisprudence at MCV from 1856 until 1871. An early member of the American Medical Association, he was professionally active and published articles on a wide variety of subjects. Joynes, an outstanding administrator, successfully guided the institution through the tumultuous years of the Civil War.

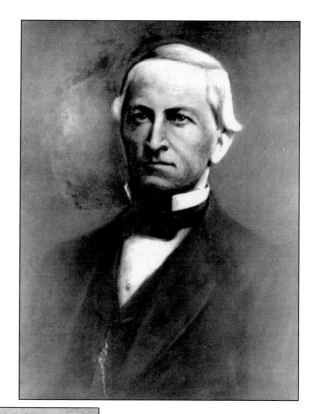

MEDICAL COLLEGE
HOSPITAL.

The Faculty are under the necessity of announcing a further increase of the charges in this establishment, in consequence of the steady and heavy increase of its expenses. Notwithstanding the advance of rates adopted during the past year, the expenditures, owing to the exorbitant prices of supplies of every description, have, for several months past, exceeded the receipts; and, in view of the additional burden now arising from the increased rates of hire for nurses and other servants, the alternative is forced upon the Faculty of closing the Hospital, or adopting such a scale of charges as may protect it from serious loss. Unwilling to take the former course, they have fixed upon the following charges, to take effect **on and after the 10th instant,** both as to new patients and those remaining in the Hospital on that day:

White persons in private rooms, $20 per week, or $3 50 per day for less than a week.

White persons in public wards, $15 per week, or $2 50 per day.

Negroes, $12 per week, or $2 per day.

These charges include board, medical attendance, medicines, nursing and washing. A small fee, (varying from $2 to $30,) will be charged, as heretofore, for surgical operations.

A comparison of the above rates for white persons with the cost of board and medical treatment in a hotel or boarding-house, shows that the advantage of economy is largely in favor of the Hospital. It is also evident that negroes can be treated more cheaply in the Hospital, at this time, than anywhere else.

Payment for the first week must be made in advance. After the first week, payment must be made weekly, or a written obligation given to settle all dues on the discharge of the patient. Where the party is a non-resident of Richmond, or is unknown to the Officers of the Hospital, payment must be guaranteed by some known and responsible resident of the city. The impossibility of obtaining supplies, except for cash, compels the requirement of these conditions.

OFFICERS:

President—L. S. JOYNES, M. D.

Attending Surgeon—JAMES H. CONWAY, M. D.

Resident Physicians—HENRY B. MELVIN, M. D.

MARSHALL T. BELL, M. D.

Steward—N. G. TURNLEY.

Jan. 5, 1863.

BROADSIDE, MEDICAL COLLEGE HOSPITAL, 1863. MCV struggled to maintain its hospital during the war and repeatedly raised the charges for care. As was customary, the faculty set separate rates for whites and African Americans. The hospital provided care for sick and wounded Confederate soldiers in the early years of the conflict. By 1864, the faculty had closed the hospital and rented the facility as a rooming house.

15

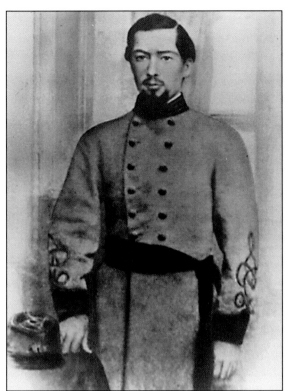

SIMON BARUCH, 1862. Baruch (1840–1921), the father of American hydrotherapy, graduated from MCV in 1862. Like other young medical graduates, he was immediately commissioned an assistant surgeon in the Confederate army, even though he lacked extensive medical experience. Baruch's son Bernard donated funds to MCV in the late 1930s for the renovation of the Egyptian Building. The Simon Baruch Auditorium within this building is named in his honor.

JAMES B. McCAW, 1850s. The fourth in a line of Virginia physicians of the same name, McCaw (1823–1906) began his 43-year association with MCV in 1858 as professor of chemistry. During the Civil War, he gained fame as the able administrator of Chimborazo Hospital, one of the Confederacy's largest medical facilities, located on the eastern end of Broad Street. McCaw taught throughout the war and frequently took his students to Chimborazo for added clinical experience. (Image courtesy of the National Library of Medicine.)

Two

RIVALS AND REFORM

1866–1924

The Medical College of Virginia escaped the evacuation fire that devastated much of Richmond in April 1865, only to sustain damage from the federal troops who occupied the college buildings following the close of the Civil War. Determined to continue their instructional program, the faculty repaired the buildings and presented medical lectures on schedule in the fall of 1865. The Virginia General Assembly provided financial relief by appropriating $1,500 to reimburse the faculty in 1866, thereby instituting the first annual appropriation for the school. In spite of this financial support, the school struggled to survive throughout Reconstruction.

Other difficulties plagued the school during the last quarter of the 19th century. Internal faculty disagreements prompted several resignations in the 1880s. Factions emerged within the Richmond medical community, and conflicting philosophical stances sometimes escalated into full-fledged fights during professional meetings. In 1893, Hunter Holmes McGuire, a former professor of surgery at MCV, organized the University College of Medicine (UCM) just blocks from the Egyptian Building. UCM proved a formidable rival for MCV; the two schools competed for students over the next 20 years. The educational leader Abraham Flexner evaluated both colleges in 1909, starting a dialogue that resulted in a 1913 merger.

This new combined medical school began to modernize in the years preceding World War I by enlarging the clinical facilities and bolstering the educational program. These changes came at a critical juncture, just as the Council on Medical Education of the American Medical Association threatened to downgrade MCV's "Class A" rating in the fall of 1919.

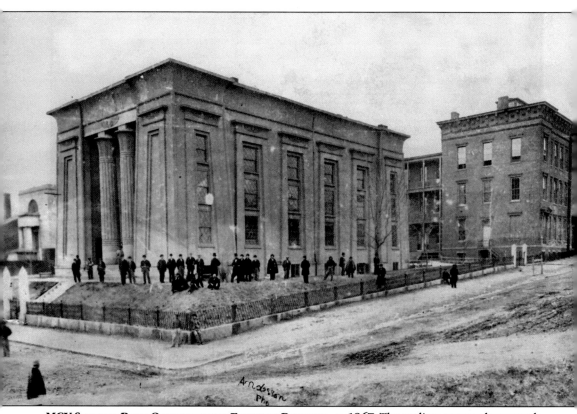

MCV Student Body Outside of the Egyptian Building, *c.* **1867.** The earliest extant photograph of the college buildings shows the entire student body in the late 1860s outside of the Egyptian Building with the college hospital on the right. The hospital, closed for financial reasons in 1864, did not reopen until 1867. Enrollment fell in the immediate aftermath of the Civil War, as few Virginians had the financial resources to attend medical school. The academic year, which had been shortened during the war, expanded to five months in 1867, the same year that the college enlarged the faculty to eight. The college also opened its first outpatient clinic, in cooperation with the City of Richmond and the Freedman's Bureau, "for the relief of the sick poor, both white and colored." The new clinic allowed the faculty to expand clinical instruction for students. In spite of these improvements, enrollment remained low. Only 20 students matriculated for the 1870 term.

1867: 1st outpt clinic

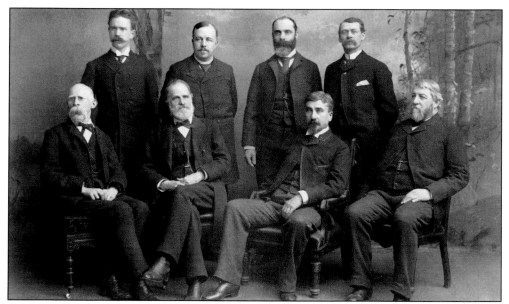

MCV FACULTY, *c.* **1890.** A growing dissension among the faculty concerning the educational program prompted several resignations in the 1880s. The regrouped faculty posed for this formal photograph. Pictured from left to right are (seated) William Henry Taylor (1825–1917), John S. Wellford (1825–1911), John Syng Dorsey Cullen (1832–1893), and Martin L. James (1829–1907); (standing) Lewis C. Bosher (1860–1920), Christopher Tompkins (1847–1918), Henry H. Levy (1850–1921), and John N. Upshur (1848–1924).

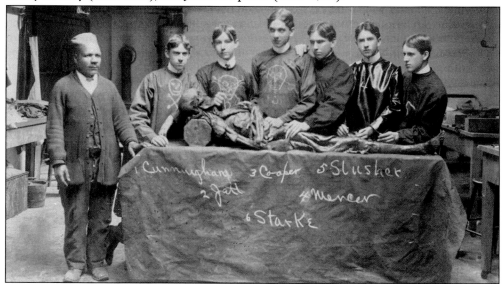

ANATOMY LAB, 1900. Gross anatomy lab has been an integral part of medical education for centuries. To show off their newly gained knowledge of human anatomy and their comfort in dealing with the dead, students would record their experience in these photographs. Shown from left to right in the dissecting room on the top floor of the Egyptian Building are Chris Baker, who managed the cadavers and helped students to learn their anatomy, and students Colbert Cunningham, Samuel Jett, Frank Cooper, Charles Mercer, William Slusher, and Edward Starke.

LABORATORY BUILDING, *c.* 1905 (TOP), AND PATHOLOGY LABORATORY, 1913 (BOTTOM). MCV expanded its educational facilities by constructing this laboratory building in 1896, the first new college structure since 1861. It provided modern classroom space and, more importantly, properly equipped laboratories for teaching such subjects as pathology, histology, and bacteriology, which had been added to the curriculum by the end of the 19th century. The faculty also extended the medical curriculum to four years beginning with the 1899–1900 term. Tuition at the turn of the 20th century stood at $65 per term, a reduction from the $135 charged when merely three terms of lectures constituted the graduation requirements. These modifications helped the school to attract a larger student body, as the 1899–1900 enrollment topped 150 students. The laboratory building was razed in 1917 to allow the construction of Dooley Hospital.

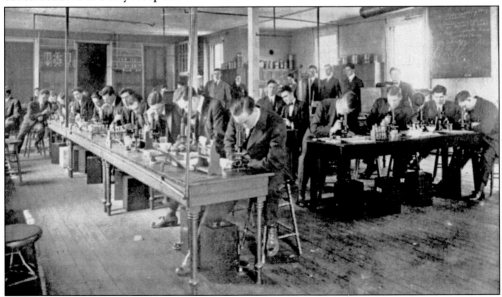

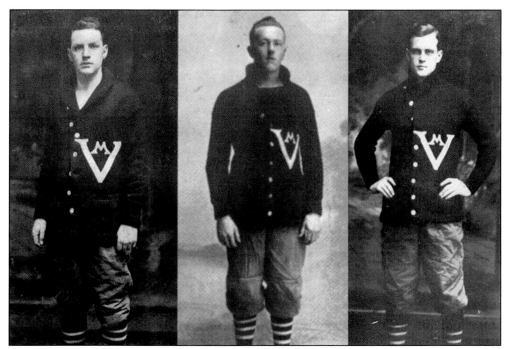

FOOTBALL PLAYERS GEORGE SCHENCK, EDWARD HARDIN, AND THOMAS HARDY, 1914 (TOP) AND BASEBALL TEAM, 1918 (BOTTOM). MCV began intercollegiate athletics in the early 20th century. Eligibility rules were more relaxed than current regulations, and some students continued their college athletic careers once they enrolled in medical or dental school. Other students, who had no previous college experience prior to matriculating at MCV, enjoyed the opportunity to participate in team sports. In the years before World War I, MCV fielded a football squad and competed against such teams as Virginia Tech, Wake Forest, and William and Mary. The MCV Medicos also participated in baseball, basketball, tennis, wrestling, swimming, and golf. The basketball program continued through 1963, when MCV gave up its intercollegiate program to focus on intramural athletics.

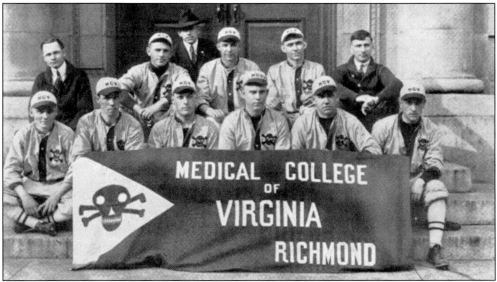

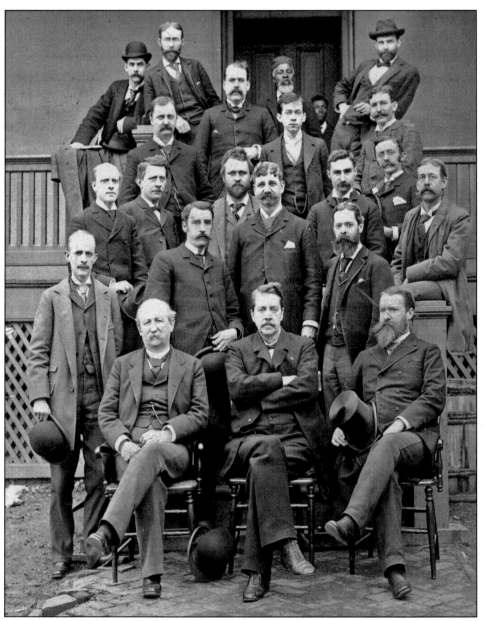

FACULTY OF THE UNIVERSITY COLLEGE OF MEDICINE, 1894. Hunter H. McGuire (1835–1900) selected some of Richmond's most prominent physicians for the faculty of his new medical school, the University College of Medicine. The school opened on October 3, 1893, with separate schools for medicine, dentistry, and pharmacy with graded curricula. McGuire also initiated a training program for nurses in UCM's major clinical facility, the Virginia Hospital. Pictured from left to right are (first row) Thomas J. Moore, Hunter H. McGuire, and L. M. Cowardin; (second row) William S. Gordon, J. Allison Hodges, and Joseph A. White; (third row) T. Wilber Chelf, Landon B. Edwards, Moses D. Hoge Jr., Jacob Michaux, Charles L. Steel, John F. Winn, and Charles H. Chalkley; (fourth row) Paulus Irving, Stuart McGuire, and W. T. Oppenhimer; (fifth row) Charles V. Carrington, James N. Ellis, Edward McGuire, morgue attendant Tom Haskins, and John Dunn.

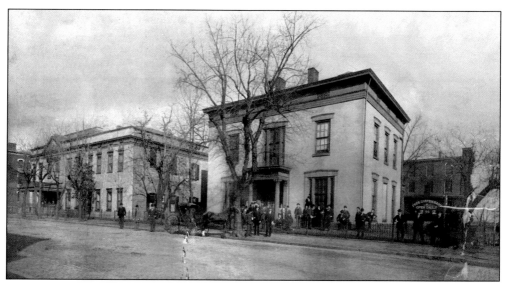

UNIVERSITY COLLEGE OF MEDICINE, 1894. UCM modified the Bruce-Lancaster House (right), the former residence of Confederate vice president Alexander Hamilton Stephens (1812–1883) at the corner of Twelfth and Clay Streets, to serve as their educational building. The neighboring Caskie-Brockenbrough residence was transformed into the Virginia Hospital. Within three years, the school required additional space and undertook a major renovation of both structures.

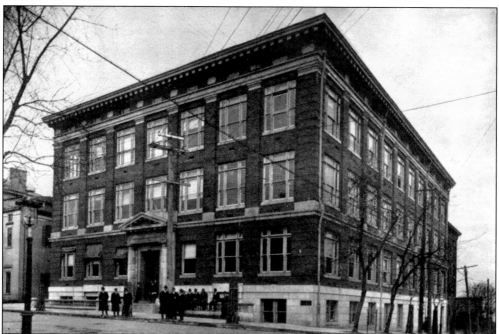

MCGUIRE HALL, 1914. On January 6, 1910, a major fire broke out in the Virginia Hospital that consumed the adjoining UCM educational building. Two years later, the college dedicated this modern, fireproof structure financed through gifts from the citizens of Richmond. Following the merger of the medical schools, MCV named the building for UCM founder Hunter McGuire. A fourth floor was added in 1940–1941.

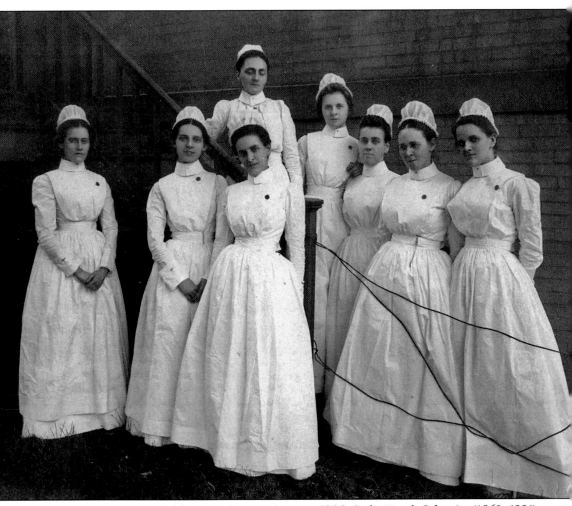

OLD DOMINION HOSPITAL TRAINING SCHOOL CLASS OF 1900. Sadie Heath Cabaniss (1863–1921) organized a nursing training program at the Old Dominion Hospital in 1895. Cabaniss, a graduate of the Johns Hopkins Hospital School of Nursing, laid the foundation for professional nursing in Virginia. She and the class of 1900 started the Richmond Nurses Settlement, which subsequently became the Instructive Visiting Nurses Association (IVNA). Cabaniss led the movement to secure licensing regulations for Virginia and helped to create the Virginia State Association of Nurses. The current VCU nursing program traces its roots from Old Dominion Hospital's program and three others: the Virginia Hospital, Virginia City Hospital, and Memorial Hospital. Prominent women from Virginia's first generation of professional nurses led each program. Pictured from left to right are Lillie V. Moore, Anne Gulley, Cabaniss (on steps), Rosabelle Parkins, Laura A. Henninghaussen, Frances Perry, Elizabeth Cocke, and Nannie J. Minor.

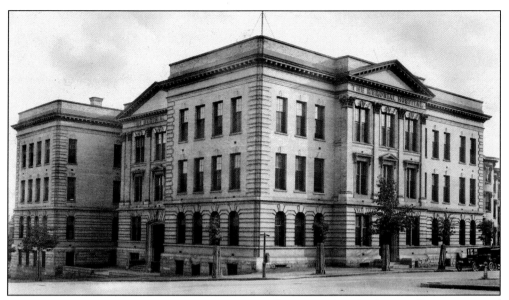

MEMORIAL HOSPITAL, C. 1925. This hospital, originally named the Charlotte Williams Memorial Hospital, opened on July 27, 1903. Constructed on the corner of Twelfth and Broad Streets at a cost of $193,800, the independently managed facility served as the teaching hospital for MCV from the outset. As a part of the merger agreement between the two Richmond medical schools, the hospital board deeded the facility and its debt to MCV in 1913.

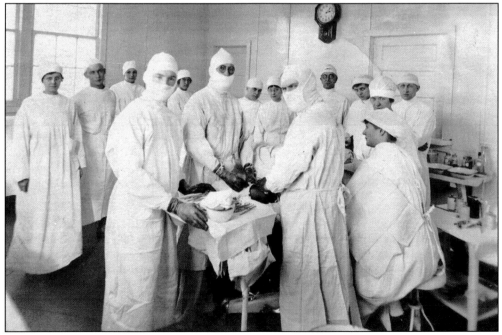

MEMORIAL HOSPITAL OPERATING ROOM, 1913. MCV surgeon George Ben Johnston (1853–1916) and other prominent physicians performed new and innovative surgical procedures in the modern operating rooms within Memorial Hospital. In keeping with the most advanced surgical practices of the time, the surgeons have donned masks, gowns, and gloves for this operation in 1913.

25

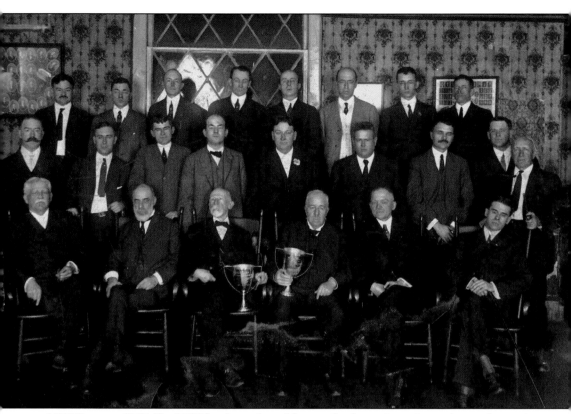

MCV FACULTY, 1913. The MCV faculty gathered for one final meeting prior to the amalgamation with UCM. The boards of each of the two medical schools dismissed their respective faculty following the close of the 1912–1913 academic term. The photograph, taken inside the Egyptian Building, shows the interior design of the structure prior to its extensive renovation and remodeling in 1939. On this evening, William Henry Taylor, class of 1856, and Christopher Tompkins, class of 1870, were honored for their long years of service to their alma mater. Tompkins, who served as dean from 1892 until 1913, pushed MCV to keep pace with UCM. Pictured from left to right are (first row) George Ben Johnston, Henry H. Levy, Taylor, Tompkins, Charles A. Blanton, and J. Fulmer Bright; (second row) Lewis C. Bosher, J. McCaw Tompkins, C. C. Coleman, Clifton M. Miller, William P. Mathews, Frank M. Reade, J. Shelton Horsley, Ennion G. Williams, and William G. Christian; (third row) Charles Robins, Greer Baughman, R. H. Wright, E. P. McGavock, A. Murat Willis, Beverley R. Tucker, Manfred Call, and Charles M. Hazen.

CATALOGUE AND ANNOUNCEMENT

of the

Medical College of Virginia *and the*

University College of Medicine

CONSOLIDATED

RICHMOND, VIRGINIA

1919–1920

MEN AND WOMEN ADMITTED ON EQUAL TERMS

THIS ANNOUNCEMENT PERTAINS TO THE

Schools of Medicine, Dentistry and Pharmacy

MEDICINE, beginning on page 9.
DENTISTRY, beginning on page 61.
PHARMACY, beginning on page 97.

TITLE PAGE, *BULLETIN OF THE MEDICAL COLLEGE OF VIRGINIA*, **1919–1920 (TOP), AND THE WOMEN'S CLUB, 1921 (BOTTOM).** As a war expedient, the Board of Visitors agreed to admit women to all programs at MCV in the fall of 1917. The first graduates were Innis Steinmetz (medicine) in 1920, Margaret E. Savage and Ruth Vincent (pharmacy) in 1921, and Esther M. Cummins, Constance O. Haller, and Tillie Lyons (dentistry) in 1922. While they excelled academically, the new students found that groups such as the Women's Club could help them acclimate to the male-dominated institution. The board originally planned to admit women just for the duration of the war, but the success of the early female medical, dental, and pharmacy students ensured their permanent place at MCV. The number of female graduates remained relatively small until the last quarter of the 20th century.

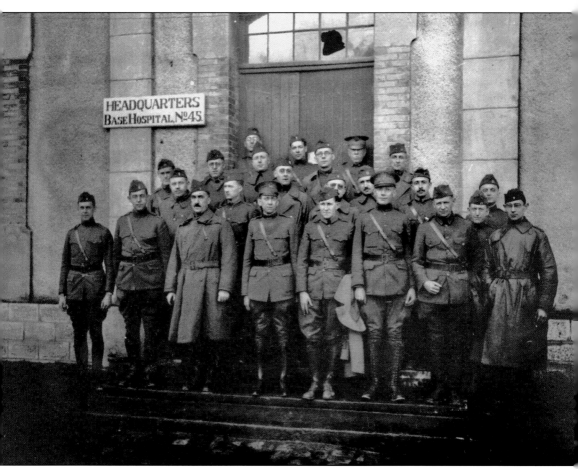

STAFF OF BASE HOSPITAL 45, 1918. MCV president Stuart McGuire (1867–1948), fourth from the left on the first row, delegated the affairs of both the college and his private practice at St. Luke's Hospital in Richmond, joining the Army Medical Service during World War I. McGuire and other physicians from MCV organized Base Hospital 45 and set sail for Europe. A group of nurses from St. Luke's Hospital, under the leadership of Ruth Robertson, accompanied the physicians and other medical personnel. The "McGuire Unit," as it became known, set up operations in Toul, France, and served for the duration of the war. Those members of faculty who remained in Richmond carried on the teaching program and coped with such domestic crises as the influenza pandemic of 1918. Classes at MCV were suspended for most of October so that medical students who had previously been inducted into the Student Army Training Corps could attend to the sick. Nearby John Marshall High School was converted into a hospital, with MCV students serving as orderlies.

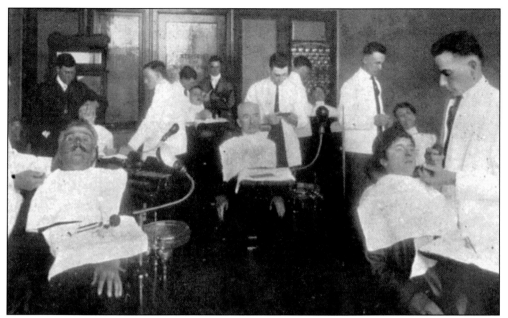

PROSTHETIC INFIRMARY, 1916 (TOP), AND THE TIDEWATER VIRGINIA DENTAL CLUB, 1917 (BOTTOM).
Following the lead of the University College of Medicine, MCV established a separate dental
school in 1897. Henry C. Jones (1849–1914) served as the first dean. His faculty consisted
primarily of physicians instead of dentists. The rivalry with the UCM dental school posed
a series of challenges for the MCV program. In 1904, UCM opposed MCV's application for
membership in the National Association of Dental Facilities. The Tidewater Virginia Dental
Club constituted one of several clubs for dental students at MCV. Students from various
regions of Virginia frequently organized clubs along geographic lines during the first quarter
of the 20th century. The dental club members posed here near the residential section of the
college. Students found room and board in these nearby residences in the years before the
existence of formal dormitories.

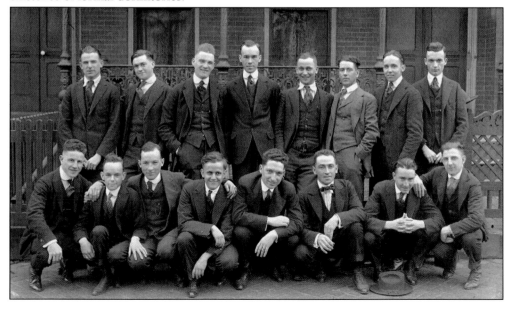

ST. PHILIP HOSPITAL, LATE 1920S (TOP), AND DOOLEY HOSPITAL, *C.* 1930 (BOTTOM). Overcrowded conditions in Memorial Hospital stimulated the college to undertake a major fund-raising campaign for new clinical facilities. Two major additions resulted. St. Philip, a 176-bed hospital for African Americans located on Marshall Street, opened in November 1920. Richmond's African American physicians could not attend to cases in this closed hospital. Throughout its 45 years as a segregated health care institution, attending privileges were granted exclusively to MCV's all-white faculty. A second hospital, designed by Noland and Baskervill, opened in October 1920. Maj. James Dooley (1841–1922), Richmond lawyer and philanthropist, agreed to donate funds for this children's hospital, which was named in his honor. The 40-bed hospital was initially designed for children with infectious diseases but was used for a variety of pediatric cases until the 1940s.

45 yrs at a
segregated healthcare
system.

Dooley →
childrens hospital
40 beds

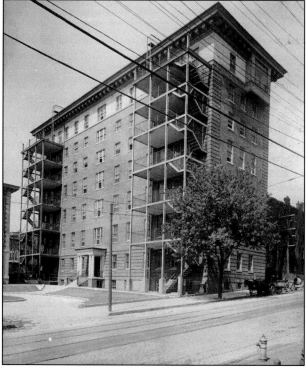

Three

BUILDING AN ACADEMIC MEDICAL CENTER
1925–1968

The educational reform begun with the Flexner Report continued in the decade following World War I as medical schools across the country began hiring full-time faculty and administrators to strengthen their instructional programs and enhance their standing with the Council on Medical Education. President McGuire urged the Board of Visitors to select a full-time administrator. The board's selection of William T. Sanger, an experienced educator, proved to be the key to the college's future.

From 1925 to 1956, Sanger developed the physical campus, initiated new educational programs in the allied health field, promoted health sciences research, encouraged curricular reform, recommended the creation of a foundation to manage gifts and bequests to the college, and raised the standing of the largely provincial medical school. He bequeathed to his handpicked successor, Robert Blackwell Smith Jr., an efficiently managed institution poised to enter the next phase of development. Smith, who had served for two years as assistant president, quietly pushed to develop clinical and scientific investigation at the institution and selected new full-time faculty with strong research interests.

MCV celebrated its 125th anniversary in 1963 at the conclusion of a successful $10.5-million capital campaign. A year later, the medical school would implement a major curriculum reform in a modern instructional and laboratory building. By the mid-1960s, the transplant program was bringing international recognition to the college. In spite of the growth and accomplishments, MCV remained a freestanding medical school. Without the infrastructure a comprehensive university could provide, the college's ability to compete for federal research funds would be compromised.

31

SUBSCRIBE TO
SKULL and BONES

ADVERTISE IN:
SKULL and BONES

SKULL AND BONES

THE NEWS WEEKLY OF THE MEDICAL COLLEGE OF VIRGINIA

VOLUME 3 MEDICAL COLLEGE OF VIRGINIA, APRIL 10, 1925 NUMBER

President and President-Elect of Medical College of Virgini

DR. SANGER HEAD OF MEDICAL COLLEGE OF VIRGINIA

Elected President in March and Succeeds Dr. McGuire.

Outlines Policies and Expects Support of Alumni.

At a meeting of the Board of Visitors of the Medical College of Virginia held in March, Dr. W. T. Sanger, Secretary of the Virginia State Board of Education was elected president of the college succeeding Dr. Stuart McGuire.

Dr. McGuire has for several years been anxious to be relieved of his duties as president, and has advocated that the institution secure a full-time president.

Dr. Sanger is 39 years of age. He was born at Bridgewater in Rockingham County, Virginia. He is a son of S. F. Sanger, a native of Augusta County, Virginia, who was a minister of the church of the Brethren and one of the promoters of Bridgewater College. His mother died when Dr. Sanger was thirteen years of age. She was before her marriage Susan Thomas, of Rockingham County.

Dr. Sanger attended private elementary school at Bridgewater; one room school at Calverton and graded school at Manassas. His family moved to South Bend, Indiana, in

DR. STUART McGUIRE DR. WM. T. SANGER

SKULL AND BONES, **1925.** Students started a weekly newspaper in 1915. Although regular publishing of a student paper stopped in the 1950s, the publication has enjoyed several revivals, most recently in the fall of 2005. This April 1925 issue reports the Board of Visitors' election of William T. Sanger (1885–1975) to be the first full-time president for MCV beginning July 1, 1925. The Virginia-born Sanger trained with G. Stanley Hall (1844–1924) at Clark University, where he received his Ph.D. in 1915. Prior to his appointment at MCV, he taught at Bridgewater College, Harrisonburg State Teachers' College, and the University of Virginia. He also served as the first full-time executive secretary of the Virginia State Teachers' Association and in an administrative position with the State Board of Education. A man of action, the indefatigable Sanger immediately went to work to build a modern medical school. He served as president until 1956 and as chancellor for three years thereafter. Against seemingly insurmountable odds, he laid the foundation for the VCU Medical Center.

CABANISS HALL, 1944. Sanger's first construction project completed in 1928 was a new dormitory and classroom building for the School of Nursing. Located at 220 East Broad Street, the building was named for Sadie Heath Cabaniss. It served as the home of the School of Nursing until 2006.

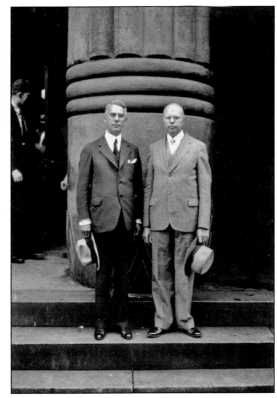

J. FULMER BRIGHT AND PRESIDENT SANGER, 1930S. Richmond mayor J. Fulmer Bright (1877–1953), at left, who served from 1924 until his electoral defeat in 1940, frequently differed with Sanger over his building plans for the college. Sanger generally outmaneuvered the recalcitrant Bright, a MCV graduate who taught at his alma mater before entering public service.

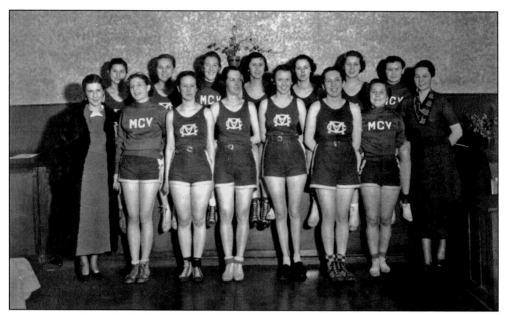

WOMEN'S BASKETBALL TEAM, 1935 (TOP), AND NURSING CLASS OF 1928 (BOTTOM). Sanger took a special interest in nursing education throughout his tenure. Shortly after his arrival, he made the nursing program an academic school with its own dean. Nursing graduates joined other MCV students at the annual commencement exercises. In 1927, MCV formed its first women's basketball team, the Sawbonettes. They competed against other Richmond-area women's teams for a number of years, eventually adopting the nickname the Medicettes to complement the name of the men's team, the Medicos. Nursing students also began to serve as members of student government and on the staff of student publications, including student newspaper and the college yearbook, *The X-ray*. Although nursing students now had greater opportunities to participate in college activities, their behavior was strictly controlled by rules and regulations that applied exclusively to female students.

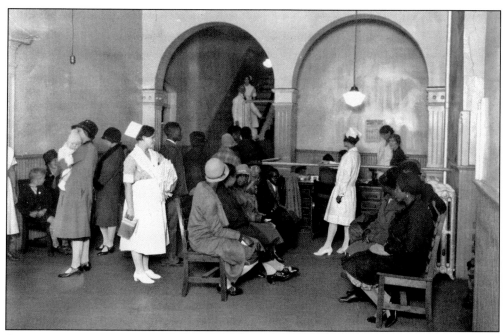

OUTPATIENT CLINIC, *c.* 1930. As a Virginia institution, MCV followed the local customs and practices when it came to race relations. The waiting area for the outpatient clinic housed in the old Virginia Hospital had separate sections for white and African American patients. Similar practices were followed in all Southern hospital wards. The educational programs remained closed to African Americans until 1951, when Jean Harris (1931–2001) enrolled in the School of Medicine.

A. D. WILLIAMS CLINIC, 1937. MCV lacked a modern laboratory building and outpatient clinic, a fact noted by the Council on Medical Education. The Depression stalled Sanger's plans for the facility. Under increased pressure to act following the council's visit in 1935, Sanger secured a grant from the Public Works Administration and an anonymous donation to cover the $600,000 cost of construction. In the 1950s, MCV named the building for A. D. Williams (1871–1952), the previously anonymous donor.

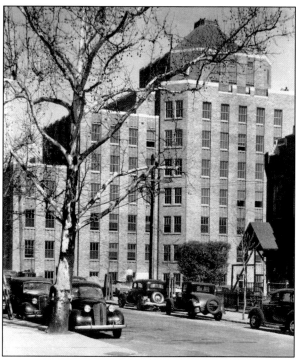

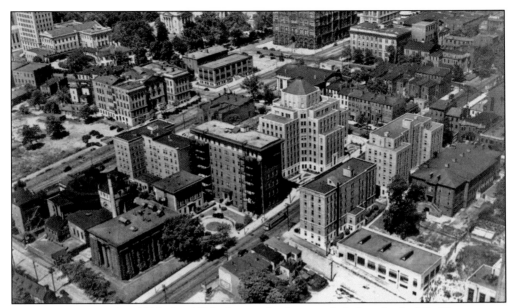

AERIAL VIEW OF MCV, 1938. By 1938, Sanger had expanded the physical facility west to Thirteenth Street and south to the 500 block of Twelfth Street, just beyond Clay Street. MCV purchased property in the former residential area as soon as it became available. Old homes were razed to make way for dormitories, a college library, and the new laboratory and clinic building.

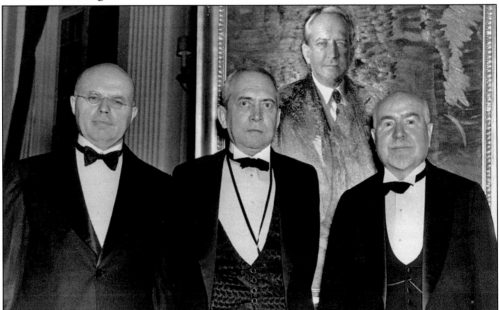

THREE MCV PRESIDENTS, 1938. Sanger staged an elaborate celebration to mark the 100th anniversary of the founding of the medical school. MCV collaborated with the City of Richmond and the various professional associations on a major exhibition to chronicle the development of the health professions and the college. All three MCV presidents attended the centennial luncheon held in June 1938. From left to right are Sanger, McGuire, and Samuel Chiles Mitchell (1864–1948), who served from 1913 to 1914.

1938 Founding of the medical school

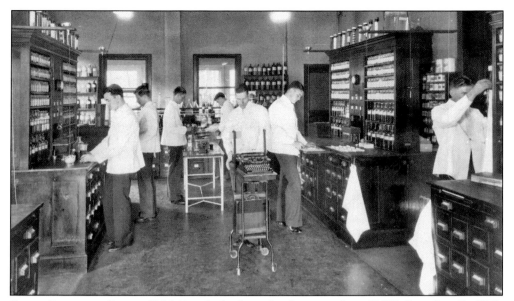

SENIOR PHARMACY CLINIC, 1933. Faculty had taught pharmacy from MCV's founding. In 1879, the college's charter was amended, authorizing the school to grant a pharmacy degree. The School of Pharmacy at MCV, formally organized in 1898, granted a pharmacy graduate diploma (Ph.G.) until the mid-1930s, when the baccalaureate degree was conferred.

STUDENTS ON HARVEY HAAG DAY, 1945. Over the years, a number of memorable individuals have served on the MCV faculty. Harvey B. Haag (1900–1961), professor of pharmacology, was a particular favorite. His research interest in the pharmacology of nicotine and alcohol made for good lecture material. Once a year, generally on the day Haag would lecture on alcohol, students came to class resembling their beloved instructor complete with pipes and waxed mustaches.

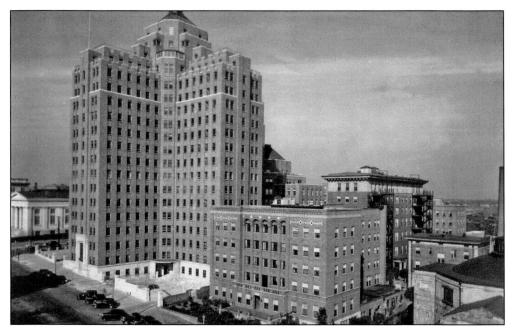

MCV Hospital, c. 1948. Sanger's greatest triumph may have been the construction of the MCV Hospital at Twelfth and Broad Streets. Facing opposition from Mayor Bright and lacking funding, Sanger ultimately persevered and secured a modern hospital for the college. The art deco structure, opened in 1941 and designed in the shape of a Maltese cross, cost $2.5 million and was funded in part by a Public Works Administration grant.

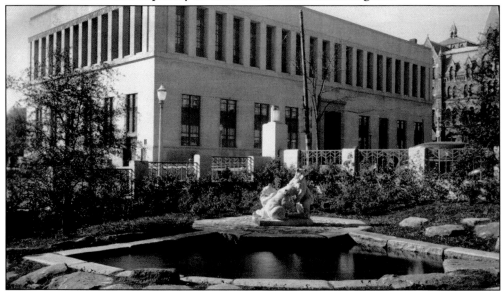

Three Bears, c. 1942. The *Three Bears* sculpture, created by Anna Hyatt Huntington (1876–1973), has longed served as an unofficial mascot and symbol for the MCV Hospitals. President Sanger saw the original sculpture at Brookgreen Gardens and convinced Huntington to make a copy for MCV. From 1941 until the spring of 1987, the stone bears watched over the Broad Street entrance to the hospital before they were moved inside to ensure their long-term preservation.

JACQUES GRAY LECTURES TO MEDICAL STUDENTS, 1943. During World War II, MCV operated continuously with an accelerated program to prepare as many health professionals as possible. Most students enrolled in the Navy V-12 or the Army Specialized Training Program. Jacques P. Gray (1900–1961) served as the first full-time dean of the School of Medicine, continuing the trend toward hiring full-time faculty and administrators.

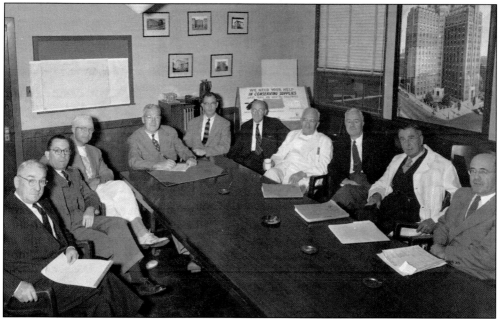

HOSPITAL ADVISORY COUNCIL, c. 1948. To manage the growing institution, Sanger created a series of committees and councils. The Hospital Advisory Council consisted of the medical department chairmen and the hospital director. Their job became increasingly complex with the opening of the new hospital in 1941.

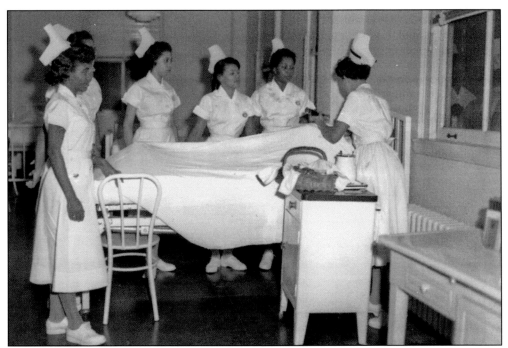

STUDENT NURSES, ST. PHILIP SCHOOL OF NURSING, *c.* 1961 (TOP), AND CLASS NIGHT, 1950 (BOTTOM). The St. Philip School of Nursing opened in 1920 to train African American women to provide care in the newly constructed St. Philip Hospital at MCV. The school, existing as a separate and segregated entity within the administrative framework of the MCV School of Nursing, trained more than 600 nurses during its 40 years of existence. In the 1930s, the school established a public health nursing program that attracted students from all over the southeastern United States. The St. Philip School of Nursing sponsored a variety of clubs, athletic activities, and social events that were held in separate dormitory and classroom facilities at MCV. Following racial integration, the Board of Visitors closed the St. Philip School of Nursing. The last class graduated in September 1962.

40

ROBERT BLACKWELL SMITH JR., 1963. Smith (1917–1971) returned to his alma mater in 1945 to teach in the School of Pharmacy. He subsequently served as dean of the school before serving as assistant president and as MCV's fourth and final president. Following the merger of RPI and MCV, Smith held the position of provost for the Health Sciences Division of the university. Failing health forced him to step down in 1969.

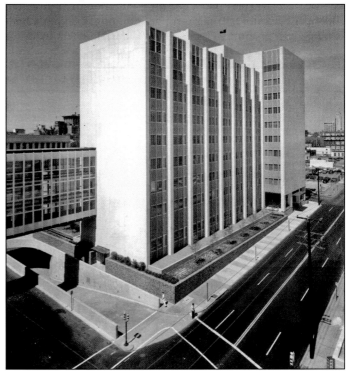

MEDICAL EDUCATION BUILDING, 1963. MCV was in desperate need of a new classroom and research building by the end of the 1950s. A successful capital campaign netted the necessary funds to match with state appropriations for a new facility fronting on Marshall Street. Several MCV administrators, including President Smith, moved their offices from clinical buildings to the new structure designed by Richmond architects Lee, King, and Poole.

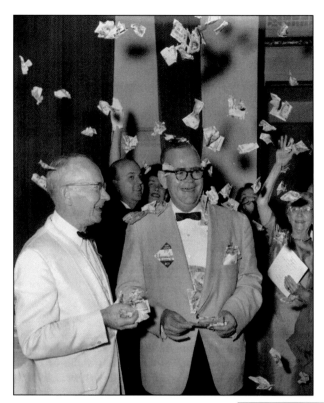

PRESIDENT SMITH ACCEPTS ALUMNI GIFT, 1964. J. Robert Massie Jr. (left) celebrates with Smith (center) the presentation of a $10,000 Alumni Association gift to the college for the creation of an alumni lounge within the college dorm complex on the northern end of campus. The MCV Alumni Association, founded in 1889, has taken an active role in college affairs since its inception.

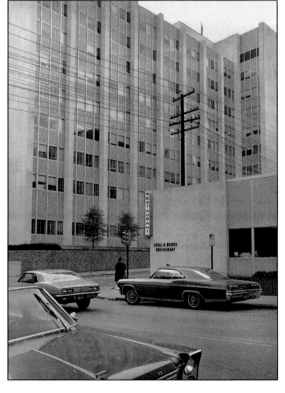

SKULL AND BONES RESTAURANT, C. 1967. The Skull and Bones Restaurant, a popular dining spot at MCV, served as an unofficial social center for students and faculty alike. Initially opened in a building located in the 1100 block of Marshall Street, it relocated to the northwest corner of Twelfth and Marshall Streets in the early 1960s. Skull and Bones was razed in 1999 to prepare for the construction of the Gateway Building.

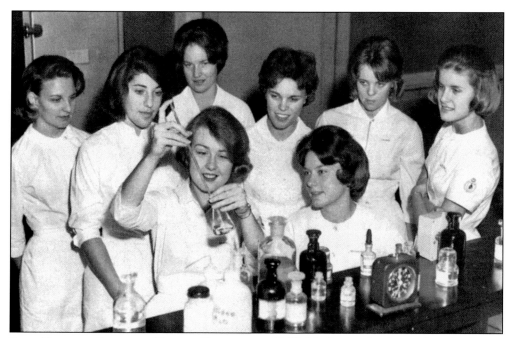

CLASS OFFICERS, SCHOOL OF MEDICAL TECHNOLOGY, 1968. Medical technology education began as a training program in 1927 and evolved into a small school complete with class officers. The election of school officers, a practice initiated in the early 20th century, continues today among the schools on the MCV Campus. The School of Medical Technology became the Department of Clinical Laboratory Sciences within the School of Allied Health Professions following the creation of VCU.

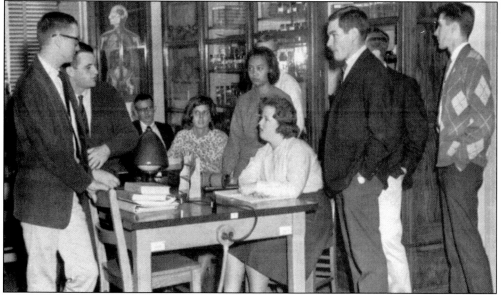

PHARMACY STUDENTS, 1968. During the 1960s, the MCV student body began to grow and diversify. The new medical education building allowed the School of Medicine to increase its enrollment and the graduate program to expand. MCV started formal graduate education in the 1930s and conferred its first Ph.D. in 1952.

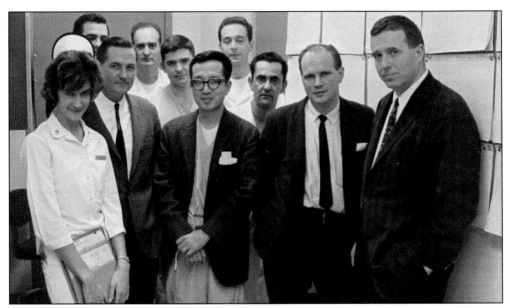

DAVID HUME AND THE TRANSPLANT SECTION, DEPARTMENT OF SURGERY, 1966. Hume (1917–1973), far right, served as chair of the Department of Surgery from 1956 until his death in a plane crash. A pioneer in organ transplant, he worked on the research team with Joseph E. Murray (born 1919) of Boston, Massachusetts, who performed the first kidney transplant in 1954. Hume established the clinical transplant program at MCV and completed his first kidney transplant at MCV in 1957.

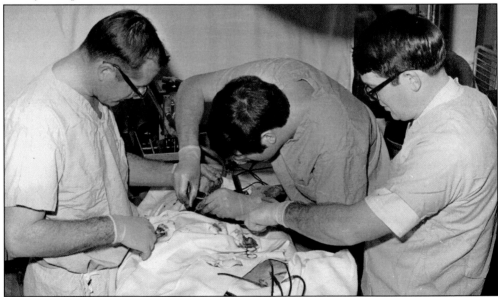

RICHARD LOWER AND SURGICAL RESEARCH ASSOCIATES, 1968. Hume recruited Richard E. Lower (born 1929) from Stanford University in 1965. At MCV, Lower, at left, conducted surgical research to perfect techniques for heart transplantation. His work was observed by Christiaan Barnard (1922–2001), who spent several months at MCV prior to his historic first heart transplant operation in 1967. Lower performed MCV's first heart transplant on May 25, 1968. It was the 9th such procedure in the United States and 16th worldwide.

Four

THE GENESIS OF A PROFESSIONAL SCHOOL
1917–1944

The turn-of-the-century Spanish-American and Boer Wars focused international attention on a number of health care and social issues. A new model of education, which combined hands-on social welfare training in the community with academic coursework designed to prepare students for professional careers, constituted one response to these problems. These service-oriented careers were considered acceptable occupations for middle-class young women, allowing them to enter the public sphere in unprecedented numbers.

This educational model already employed in England and the northeastern United States urban areas was still new to the South when the Richmond School of Social Economy opened its doors just blocks from the Medical College of Virginia. Dean Henry H. Hibbs Jr. partnered with Rev. J. J. Scherer to shepherd this enterprise through its early years, securing the financial support that allowed the institution to prosper and expand. Within a decade of its founding, the school branched out into the arts, humanities, business, and core science courses, and secured affiliation with the College of William and Mary.

Funds available through the New Deal and low real-estate demand during the Depression opened opportunities for acquisition and expansion. Inadequate facilities provided a constant challenge as the student body expanded rapidly from 30 in 1917 to 451 in 1940. Throughout these changes, the school never strayed from Hibbs's emphasis on practical education and community contact.

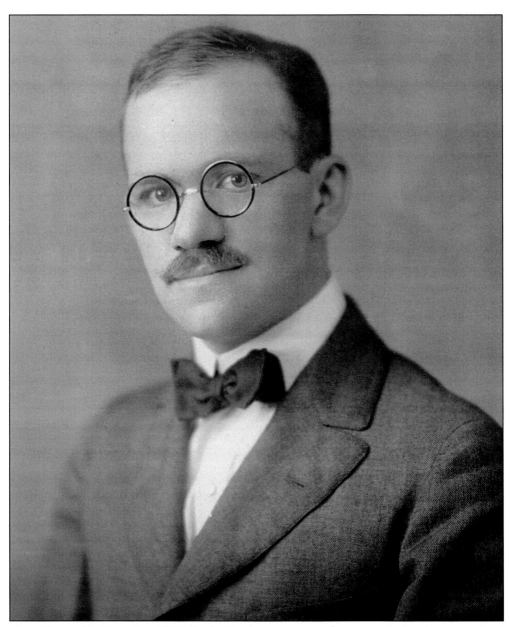

DEAN HENRY H. HIBBS JR., 1917. In 1917, when a group of community leaders organized the Richmond School of Social Economy to address urban social and health concerns and be "the first of its kind in the South," they hired the young Hibbs (1888–1977) to lead it. A Kentucky native with a Ph.D. from Columbia and experience with the Boston School of Social Work, he would lead RPI for 42 years, first taking the title of dean and later provost. Hibbs's responsibilities included raising funds, finding facilities, hiring faculty, and teaching classes. Eloquent, entrepreneurial, and intelligent, he prospered as a liaison to the financial and political forces in the city and state and to organizations active in social and health issues, including the American Red Cross, the YWCA, and the War Department during the two world wars. The strategies and philosophies of the school were dictated and overseen by Hibbs, with strong support from an ever-growing group of community leaders.

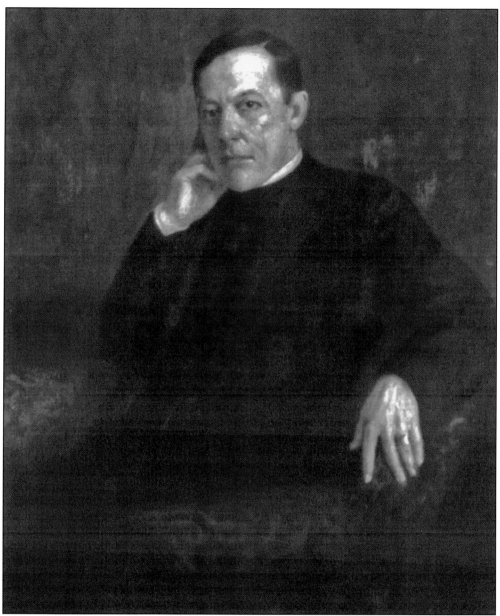

Rev. J. J. Scherer Jr., c. 1940. Second only to Hibbs in importance to the success of the school was Scherer (1881–1956), minister of the First English Lutheran Church on Monument Avenue and an active figure in Richmond's religious and social welfare enterprises. He would serve side by side with Hibbs for 40 years, leading the Board of Trustees and the RPI Foundation until his death. He had been a central figure in the organization of the Richmond Juvenile and Domestic Relations Court, with which the school briefly shared a building, and sat on the court as an associate judge. His contacts were essential for the school to receive the funding required to remain open through lean times. This portrait by Nicholas Brewer (1857–1949) was commissioned for VCU's Anderson Gallery to honor his contribution to the school. The Berkeley Apartments building at 923 West Franklin Street was purchased in 1956 for use as a dormitory and renamed Scherer Hall. (Image courtesy of VCU Anderson Gallery of Art.)

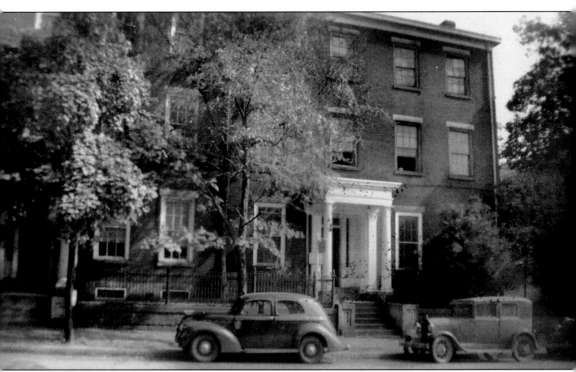

1112 CAPITOL STREET, C. 1938. Reverend Scherer secured the first home for the Richmond School of Social Work on the third floor of an old brick residence in Capitol Square across from the Governor's Mansion. Mary Dupuy, the first student to enroll, later remembered that the school shared the Capitol Street building with the Richmond Juvenile and Domestic Relations Court and bore no resemblance to a place of learning. The floor had three old bedrooms that served as classrooms and offices for Hibbs and his secretary. While there were a few shelves of books in the offices, students did most of their reading and research in the nearby State Library. The school would lease part of this city-owned building rent-free until 1919, when the vestry of the Monumental Church generously offered the use of a three-story house at 1228 East Broad Street. After night students complained that the area was unsafe, the school moved to 17 North Fifth Street, across from the YWCA, in 1923. (Image courtesy of the Library of Virginia.)

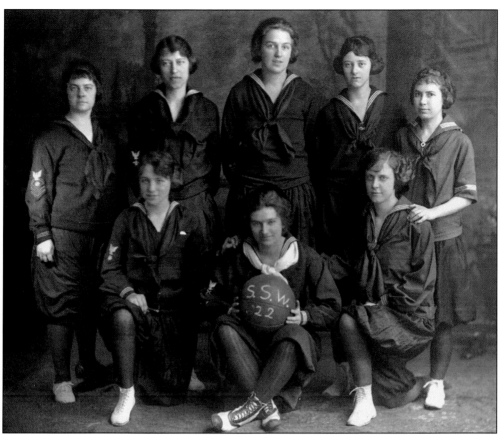

SCHOOL OF SOCIAL WORK BASKETBALL TEAM, 1922 (TOP), AND BULLETIN, 1927 (BOTTOM).
Concerns for the health and fitness of the working poor, the "Gibson Girl" ideal, and organizations such as the YWCA prompted the integration of exercise and recreation into public health curricula. Providing recreational activities for young girls became another avenue of employment for middle-class women. The Richmond School of Social Work and Public Health added a Department of Recreation in 1919. Students participated in sports at the YWCA gym and coached girls teams sponsored by area department stores, including Miller and Rhoads. The school became a training facility for professionals throughout the state in the field of recreation education. Graduates had the responsibility for not only leading recreational activities but applying general public health measures to improve nutrition, treat hygiene problems such as lice, and monitor for diseases such as tuberculosis.

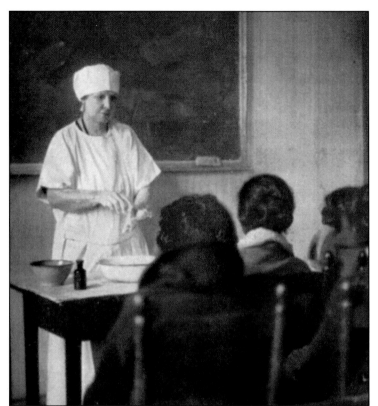

EMILY W. BENNETT TEACHING MIDWIFERY CLASS, 1920s. In the wake of World War I, Hibbs changed the institution's name to the Richmond School of Social Work and Public Health and saw financial support for students increase as a result. He drew teachers from the Commonwealth's Board of Health, including Bennett, Virginia's supervisor of midwife education and a member of the school's first graduating class in 1918.

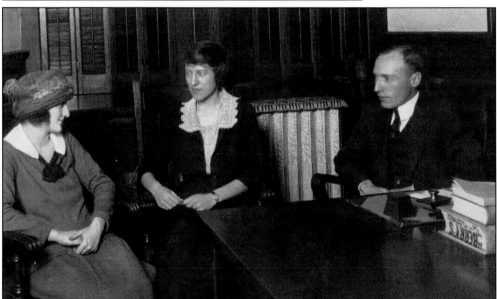

TWO STUDENTS WORKING IN THE POLICE COURT, c. 1919. The school's close proximity to the Richmond Juvenile and Domestic Relations Court and social agencies such as the City Free Dispensary for Tuberculosis, the Legal Aid Society, and the Virginia State Board of Health, all located in the 1100 block of Capitol Street, offered students valuable vocational experience while providing much-needed assistance for these offices.

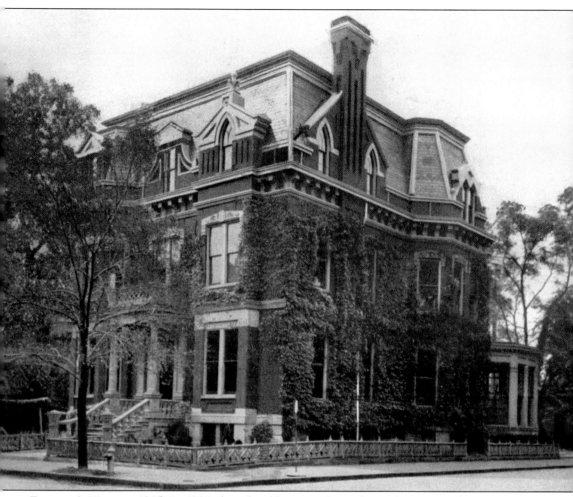

FOUNDER'S HALL, C. 1925. In 1925, the school became the Richmond Division of the College of William and Mary and acquired 827 West Franklin Street, a permanent location with room to grow. Successful Richmond merchant Edmond A. Saunders built the large mansion in the Second Empire style from 1883 to 1885. His initials can still be seen etched into the transom window at the West Franklin Street entrance. The college used the building for classrooms, offices, and as a dormitory from 1925 through 1930. In June 1930, the building was officially named Founder's Hall and began to be used primarily as a women's dormitory, with the school's cafeteria located in the basement. From the late 1960s until the early 1970s, the building served as a men's dormitory. Of the transition to being a public institution, it was later remarked that from 1925 to 1940 the school was one of the few "state-supported colleges" in the country operating almost entirely without state support.

51

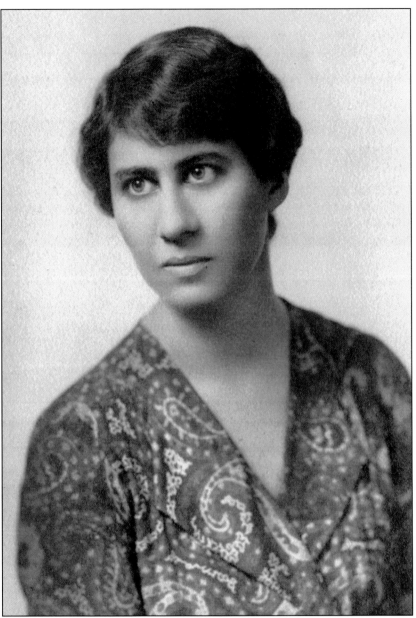

THERESA POLLAK, *c.* **1933.** Armed with a new and expanded location, Hibbs hired the Richmond-born Pollak (1899–2002) in 1928 as the first full-time art instructor for the Richmond Division of the College of William and Mary. She founded the School of Art, the forerunner to VCU's School of the Arts, and would teach at the school until her retirement in 1969. One of Virginia's most well-known artists and art educators, Pollak attended Westhampton College at the University of Richmond and is credited for introducing modern art to Richmond. She studied at the Art Students League of New York and completed post-graduate work at the Fogg Art Museum at Harvard University. In 1958, she studied with, and was heavily influenced by, abstract expressionist Hans Hofmann. In 1971, VCU's newly completed fine arts building at 325 North Harrison Street was named in her honor. Pollak continued to paint and draw the remainder of her life, exhibiting her drawings and paintings nationally.

Miss Theresa Pollak,
Richmond, Va.

Dear Miss Pollak:

Regarding the proposed use of
nude models I have consulted a number of
my associates. The final decision is that
we will not use such models for a number
of years, if ever. This will, therefore,
have to be left out of plans for the de-
velopment of the art department.

In the morning class models in
bathing suits or track suits may be used at
any time, but if used in the evening it will
be necessary for the teacher to be present
at all times.

Very sincerely yours,

LETTER TO THERESA POLLAK FROM HENRY HIBBS, 1928 (TOP), AND MALE MODEL IN ART CLASS,
1935 (BOTTOM). In this letter dated November 27, 1928, Hibbs informed the newly hired
Pollak of his views on art models' clothing. Some years later, after returning from a trip in
New York where he saw a burlesque show, Hibbs suggested to Pollak that the art models use
similar attire, bra and G-strap. A gradual migration of less and less clothing occurred, and by
the 1960s, the models were totally nude. The image below shows a model and students in the
first art studio in what is now the Shafer Street Playhouse. Pollak would later write that Hibbs
had a "love and understanding of art" and surrounded himself with paintings and sculpture.
"The Art School," she wrote, "seems a logical growth with such a man behind it."

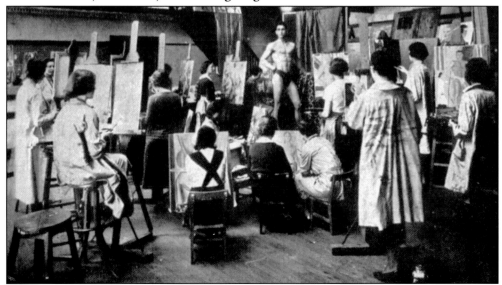

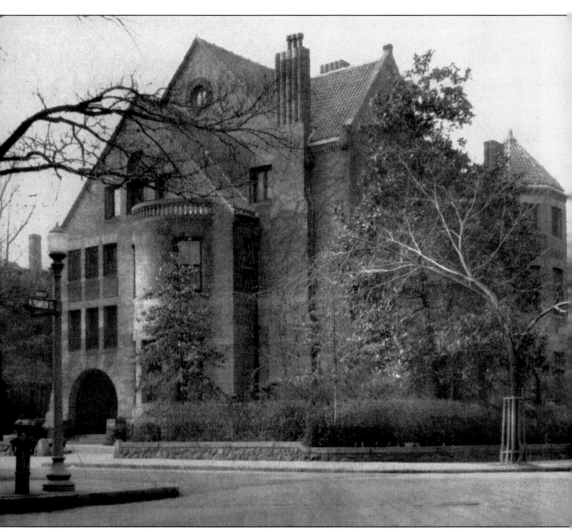

GINTER HOUSE, 1930s. Ginter House, at the corner of Shafer and West Franklin Streets, was completed in 1892 for cigarette magnate Maj. Lewis Ginter (1824–1897), one of Virginia's wealthiest men, who was responsible for developing Richmond's Ginter Park neighborhood and commissioning the Jefferson Hotel. The building, designed by architects Harvey L. Page and William Winthrop Kent, is one of the university's most architecturally significant structures and is considered one of the finest examples of Richardsonian architecture in Virginia. From 1924 through 1930, the former mansion had been home to the city of Richmond's first public library, which influenced Hibbs's decision to move the school to Founder's Hall across the street in 1925. When first purchased by the school in 1930, Ginter House was used for offices, classrooms, and the library. As the school grew, it became exclusively an administrative building for the offices of the provost, vice presidents, and other school officials. An east wing was added as part of a WPA project in 1939, and a west wing was added at the back of the building in 1949.

ART STUDIO DRAWING, 1928 (TOP), AND ANDERSON GALLERY ARCHITECTURAL PLAN, 1930 (BOTTOM). Two examples of Hibbs's entrepreneurialism are the conversion of two stables into the school's first art studio in 1928 and the Anderson Gallery of Art in the early 1930s. Portrait artist and millionaire Col. Abraham Archibald Anderson (1847–1940) financed Hibbs's plan to convert the hayloft of the carriage house behind Founder's Hall into an art studio, shown here in a drawing by Teresa Pollak. This building was later used as classrooms and a gymnasium and is still in use as the Shafer Street Playhouse. The former Ginter stable was acquired in 1930, and Anderson funded its conversion into an art gallery by Charles M. Robinson Architects. A third story was added in 1939 and a fourth in 1947. The lower stories functioned as the school's library from 1940 through 1970.

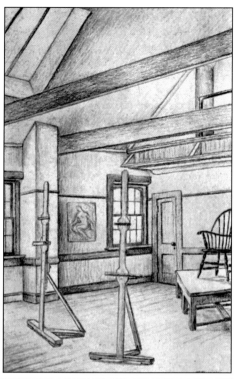

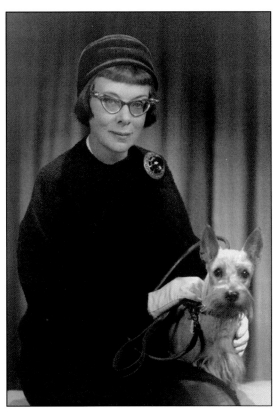

MARGARET LEAH JOHNSON, 1959. Hired to teach French and Latin in 1930, Johnson (1901–1959) was a favorite of the students and Hibbs's top assistant, becoming RPI's first dean of students in 1951. Davey, her cairn terrier, was her constant companion and a familiar sight on campus. RPI purchased the Monroe Terrace apartment building overlooking Monroe Park in 1964 as a dormitory for women and named it in her honor.

DEAN'S HOUSE (NOW THE VCU PRESIDENT'S HOUSE), 1942. Built 1894–1896 for Richmond merchant James W. Allison, 910 West Franklin Street is considered the earliest example of a Colonial Revival building in the city. Purchased by the school in 1938, the building stands directly opposite Ginter House and was used as the office and residence of Hibbs and his family. Since 1968, the building has housed the administrative offices of the VCU president.

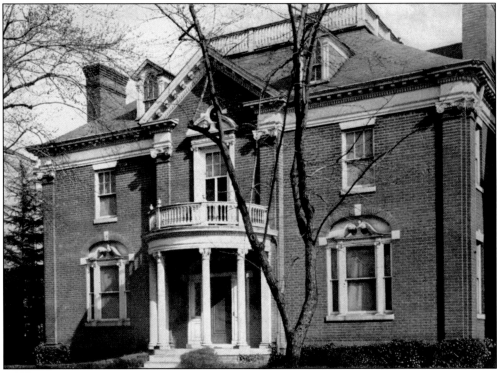

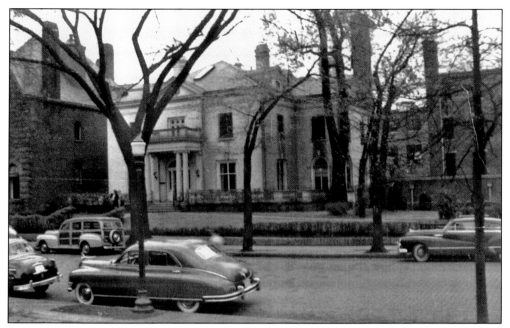

RITTER-HICKOK HOUSE, 1949. Built as a suburban Italianate villa in 1855 for merchant William Ritter, the house at 821 West Franklin Street is the oldest building on VCU's Monroe Park Campus. Belle Hickok purchased the house in 1903 and renovated it in the Georgian Revival style. The Ritter-Hickok house was acquired by RPI in 1939 and used as a women's dormitory from 1940 to the mid-1970s. It now houses university offices.

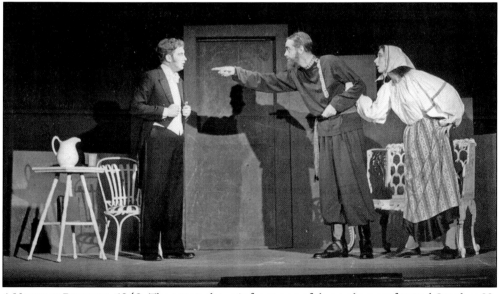

A MARRIAGE PROPOSAL, **1940.** The scene above is from one of three plays performed October 23, 1940, and directed by Raymond Hodges (1909–1984), head of what became the Department of Theatre from its founding in 1942 until his retirement in 1969. His 30 years of service were recognized in 1985 when the school named the Raymond Hodges Theatre in VCU's Singleton Center for Performing Arts in his honor.

MURAL, FOUNDER'S HALL, 1940–1941. RPI art student Maurice Bonds (1918–1995) painted this mural of Monroe Park, measuring 3.5 by 7.5 feet, as part of a WPA-funded project. Bonds would serve as an art professor at the school for 32 years, as chairman of the university's Department of Fine Arts, and later as the first head of the art history department. This mural was one of several by Bonds that were displayed in Founder's Hall in 1941. Another mural

that depicted the history of the school up through that time remained on display into the 1970s. Monroe Park is a 7.5-acre area that became a fashionable city park in the 1880s. The area west of the park is the Fan District, named for its pattern of streets, which fan out from the park. In 2004, VCU renamed its Academic Campus the Monroe Park Campus.

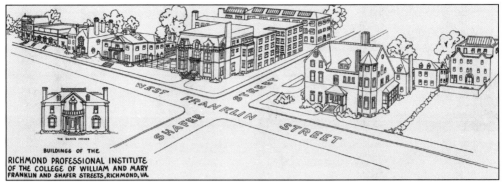

MAP OF CAMPUS, 1940. This drawing by art professor Whitfield Walker shows the corner of Shafer and West Franklin Streets, the center of RPI from 1925 through the 1960s. The campus's buildings were primarily large, elaborate, turn-of-the-century houses built by prosperous families who began to move to the western suburbs of the city in the 1920s and 1930s. The steady increase in enrollment offered Hibbs the means necessary to acquire these once-grand houses.

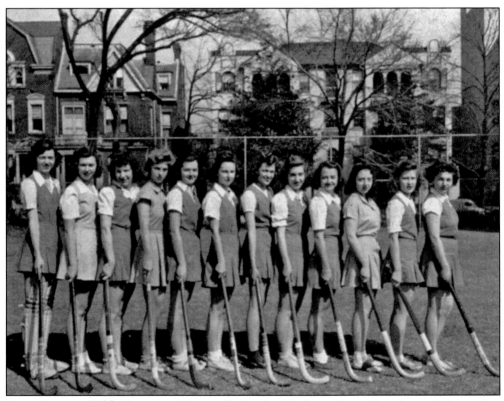

FIELD HOCKEY, 1944. The central focus of school spirit from September through November was field hockey. Dating back to 1931, it was the second-oldest intercollegiate team sport at RPI. The leg padding worn by the player at far left was the only protection afforded the goalkeeper at that time. By 1950, the popularity of men's sports had largely marginalized women's athletics.

Five

AN ENTIRELY
DIFFERENT COLLEGE
1945–1968

In RPI's 1953 pamphlet, *An Entirely Different College*, Hibbs defined a professional institute as a college or university that arranged most of its programs of study around occupations or professions. This philosophy set RPI apart, allowing students to begin working in their chosen fields as freshmen. Faculty also had much more leeway to determine which classes outside their field might be considered as core prerequisites. New programs in business, advertising, professional drama and speech, law enforcement, rehabilitation counseling, and occupational therapy prepared students for careers and addressed critical needs in postwar Richmond and Virginia.

A sharp increase in male enrollment, combined with the euphoria that followed nearly two decades of economic depression and war, produced new student social involvements. Some RPI students and faculty actively supported the civil rights movement. Many art and literature students during the late 1950s and early 1960s adopted the "beatnik" look and dress style. RPI gained a reputation as a unique institution in conservative Virginia, and this contributed to the campaign for independence from the College of William and Mary in 1962.

The post–World War II boom more than doubled the campus population over the next decade, and enrollment increased from 511 in 1944 to just under 10,000 in 1967. Construction was spurred in the 1950s and 1960s as legislators responded to the demographic realities of the baby boom. RPI had the largest enrollment on any one campus in Virginia on the eve of the creation of VCU.

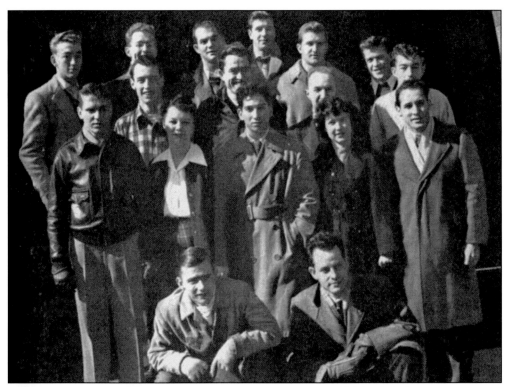

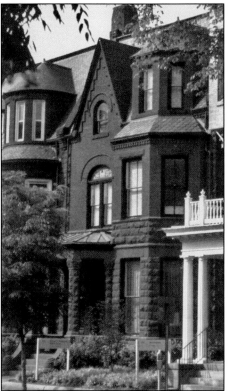

LOST BATTALION, 1947. While RPI was never exclusively for women, the first male student did not enroll until 1927. The numbers grew very slowly, and in 1940, the approximately 30 male students, mostly studying art and social work, organized themselves into the Minority Club. As a result of the G.I. Bill, men comprised 805 of the 1638 students in 1947, including 650 veterans. Male and female veterans organized the Lost Battalion Club.

THE RICHARD T. ROBERTSON ALUMNI HOUSE, 2001. After several attempts to form a sustained RPI Alumni Association misfired, the class of 1950 formed a committee that sent out a newsletter and ballot to elect officers. The organization existed for decades without institutional support until the administration drew on it to form an Alumni Council in 1979. The first RPI alumni reunion was held in 1995, and the Alumni House opened in 2000.

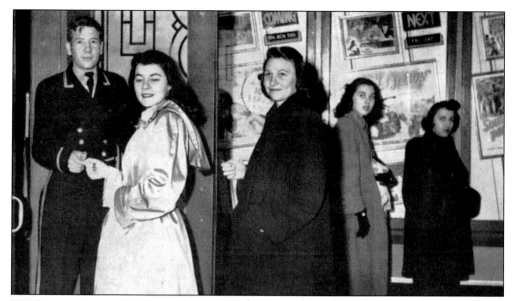

RPI Students in the Lee Theatre Lobby, 1948. Located one block from RPI, the Lee Theatre, 934 West Grace Street, opened in 1935 as a neighborhood movie theater. In 1965, it was transformed into the Lee Art Theatre, an adult film theater that also presented burlesque-style dancers. Purchased by VCU in 1993, the building re-opened as the Grace Street Theater in 1996 and now serves as the primary performing venue for the Department of Dance and Choreography.

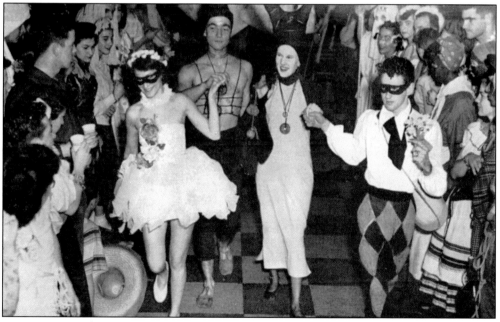

Mardi Gras, 1949. The downstairs ballroom of the Mosque, now the Landmark Theater, and the Franklin Street Gym were frequent locations for RPI social events including the formal Midwinter and May Day Dances, the Rat Week Dance, the Art Students League Carnival, the Fall Cotillion, and the German Club Dance. The Mosque also housed registration for the school for a number of years.

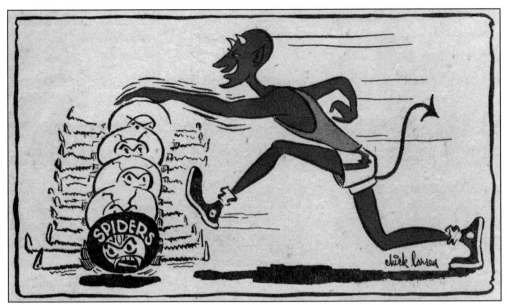

GREEN DEVILS TAKE ON THE UNIVERSITY OF RICHMOND SPIDERS, DECEMBER 1953. From 1948 through 1963, RPI's sports teams were known as the Green Devils. This drawing, by Carl "Chick" E. Larsen (1923–1991), who graduated RPI with a fine arts degree in 1954, appeared in the *Proscript*, the RPI student paper. Larson would go on to become an editorial cartoonist for the *Richmond Times-Dispatch* from 1968 to 1977.

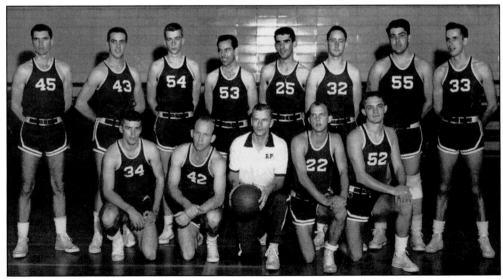

RPI BASKETBALL, 1957. Coach Ed Allen (1922–2005), kneeling in center, was RPI's athletic director, basketball coach, and baseball coach beginning in 1950. He gave up the first two positions by 1970 but coached the Green Devils and Rams baseball teams until 1975. This 1957 squad was the first winning team for RPI, finishing 13-9. Edward H. Peeples Jr. (born 1935), #32 in the back row, later taught for over 30 years at RPI, MCV, and VCU.

Tom Robbins, 1959. RPI's most famous alumnus was a key member of the Fan's beatnik community centered around the Village Café. While majoring in journalism, he wrote columns entitled "Robbin's Nest" and "Walks on the Wild Side" for *Proscript*, the student newspaper, which contained elements of his characteristic playful writing style. After graduating in 1959, Robbins (born 1936) traveled west to Washington and has penned, to date, eight novels including *Another Roadside Attraction* and *Even Cowgirls Get the Blues*.

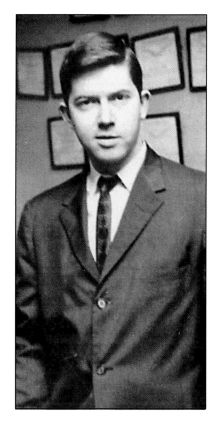

Mr. Dooley, 1964. Mr. Dooley, "keeper of the RPI Spirit," was a tradition that migrated from Emory University to RPI in 1954. Each spring, a member of the men's dormitory at 712 West Franklin Street would dress as the ghost of Mr. Dooley, ushering in a week of campus-wide high jinks culminating in his unmasking and a school dance. Two years after the dormitory was demolished in 1966, Mr. Dooley was finally laid to rest.

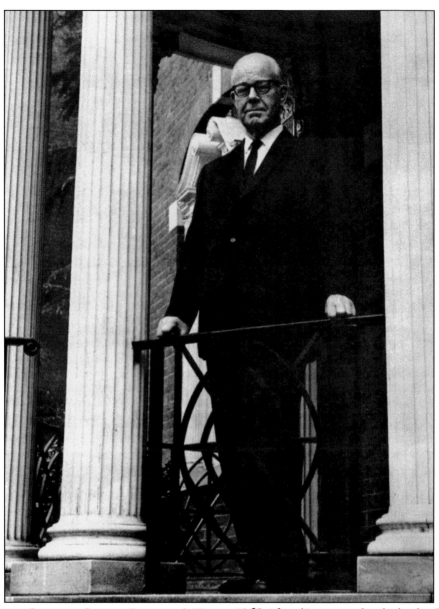

PRESIDENT OLIVER ON STEPS OF PRESIDENT'S HOUSE, 1965. After 42 years under the leadership of Hibbs, RPI was presided over by George J. Oliver (1898–1973) from 1959 to 1967. He oversaw the beginning of the transformation from professional institute to independent university. Oliver had been an administrator for the College of William and Mary prior to taking over RPI and oversaw its separation from the Williamsburg college to become an independent state-supported institution in 1962. During his tenure, RPI shifted away from purely occupational and professional education toward a more conventional breadth of programs, including the arts and sciences; erected nine new state-funded buildings; created the College of Arts and Sciences and the School of Education; and engineered a 55 percent increase in faculty and full-time teaching staff. After decades of small appropriations from the Commonwealth, the funding for these changes was provided by officials concerned that Virginia's universities could not accommodate the population boom of the 1950s and 1960s.

THE HIBBS BUILDING, *c.* **1966.** The Hibbs Building, located along Shafer Street just south of Ginter House at 900 Park Avenue, has served as the main classroom building on the Monroe Park Campus for over 40 years. Opened in February 1959, the building was the result of Hibbs's efforts to increase RPI's funding from the state during the 1950s, beginning with a presentation to Gov. John S. Battle (1890–1972) and a state budget committee pointing out that the appropriations per student at RPI were less than half that given several other schools. The governor's next budget increased appropriations to RPI by 71 percent, and significant growth in funding continued for a decade. The Hibbs Building was only the second structure built with state funds, following the West Franklin Street Gym. The building has housed the campus bookstore, the school's cafeteria, and the offices of the English department and the College of Humanities and Science, established in 1981. An addition to the Hibbs Building, completed in 1967, tripled its original size. A major renovation of the building began in 2005.

RPI Library, Early 1960s. From the 1930s through 1970, RPI's library was housed in the Anderson Building, the former Ginter stable. For most of that time, Rosamond McCannless (1904–1991) headed the library. McCannless arrived at RPI in 1938, when the library comprised just 6,000 volumes. She stepped down as head of the library in 1968 and retired from VCU in 1975 after working in the University Archives from 1970 to 1975.

Cobblestone Alley, Looking East from the Library, 1962. The cobblestone alleys that made up Richmond's streetscape led RPI to be known as the Cobblestone Campus. For nearly 40 years, the William and Mary Mews was one of the main campus thoroughfares, running between the 800 and 900 blocks of West Franklin Street and Park Avenue leading to the library. From 1956 to 1973, the student annual was titled *The Cobblestone*.

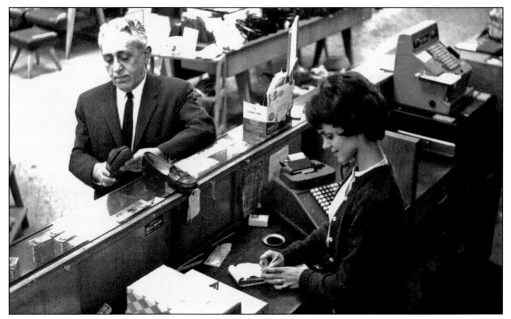

SCHOOL OF DISTRIBUTION, EARLY 1960s. Richmond had been a retail and wholesale commercial hub since its founding, and RPI turned out junior executives, personnel directors, and high school vocational teachers for that workforce. Begun in 1937 as the School of Store Service through a federal grant, the School of Distribution operated until 1969, when its advertising, retailing, and business education programs were merged into the Schools of Business and Education.

MARY EUGENIA KAPP, 1962. Kapp (1909–1983) joined the faculty at RPI in 1940 as head of chemistry, leaving during World War II to work as assistant chief of chemistry for DuPont. In 1952, she was made chair of the School of Applied Sciences while continuing to head the chemistry department until her retirement in 1972. After Kapp's death in 1983, the department was strengthened by a $1.7-million bequest from her estate.

"FREE RPI" GRAFFITI ON THE WALL OF FOUNDER'S HALL, 1962. There was strong student and faculty support for an independent RPI when legislation passed in 1962 provided for a complete separation from the College of William and Mary. Increased funding for new programs and buildings were made by recommendations from its own Board of Visitors.

VCU MASCOT, 1988. RPI chose blue and grey for its new school colors on the recommendation of the School of the Arts faculty after the school became independent in 1962, evoking Richmond as a combination of North and South. Green Devils no longer matched the color scheme, and the mascot was changed to the Rams for the fall of 1963. The 1969 merger necessitated another change, to the current black and gold.

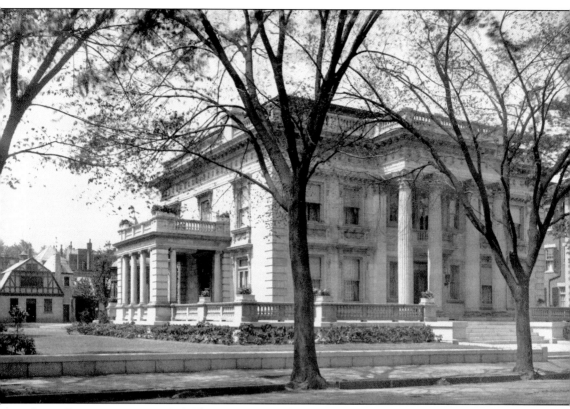

Scott-Bocock House, c. 1920. This Renaissance-derived city residence was built by Richmond's influential Scott family in 1911 and later owned by Elizabeth Scott Bocock (1901–1985), a leading voice in Richmond's architectural preservation movement. RPI began leasing the first and third floors of the main house in 1964, and Bocock continued living on the second floor until her death, after which the floor was turned into rented apartments. In 2002, the university formally purchased the building and its carriage house, which had also served as apartments. It was partially renovated and redecorated for tours as a fund-raiser for the Richmond Symphony that same year, and it now houses the Office of University Advancement and hosts many of the university's most important events. The house possesses many fine architectural features, from the Louis XVI entrance hall with a grand staircase to the metal-and-glass conservatory.

SCOTTISH RITE TEMPLE, 1970. Acquired in 1965, this building at the northwest corner of North Harrison Street and Park Avenue is another example of the school's creative solutions to accommodate its growth. Used previously by Richmond area members of the Scottish Rite, a Masonic fraternity, the building housed RPI's Gaslight Theater, art classroom space, and a basement cafeteria.

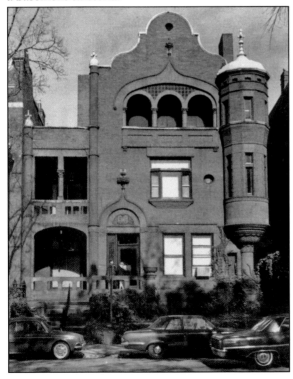

MILLHISER HOUSE, 1965. One of the most exotic buildings in Richmond is the house at 916 West Franklin Street, built from 1891 to 1894 for the Millhiser family. Purchased by the school in 1964, it served as the student center for many years. The campus radio station, the offices of the student newspaper, and the Honors Lounge were all located here. Today, the building houses the Center for International Programs. (Copyright *Richmond Times-Dispatch*, used with permission.)

JOHNSON HALL, 1970S. Used as a dormitory since its acquisition by RPI in 1964, Johnson Hall stands 12 stories high directly west of Monroe Park at the corner of Laurel and West Franklin Streets. Formerly the Monroe Terrace Apartments, a luxury high-rise facility built from 1912 to 1915, this dormitory holds just over 500 students. Johnson Hall was dedicated on October 26, 1968, and named for Margaret Leah Johnson.

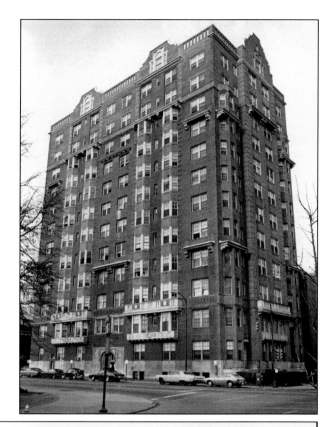

Beards, Long Hair, Cut Short in Court

The highest court in the land this week ended, for the time being at least, the question of whether a school may require certain standards of dress and appearance.

The United States Supreme Court Monday refused to hear the appeal cases of three former students preme Court which affirmed the college's right to demand such standards as dress and appearance.

The plaintiffs in the case, Norman T. Marshall, Robert D. Shoffner and Salvatore Federico, attempted to register for fall classes

U.S. SUPREME COURT REFUSES APPEAL FROM RPI STUDENT, *PROSCRIPT*, NOVEMBER 10, 1966. In 1966, the U.S. Supreme Court let stand a state appeals decision that had affirmed RPI's right to demand standards in regards to dress and appearance. The appeal had been sought by Norman T. Marshall, one of three students that had been refused admission in 1965 because of their long hair and beards. By 1967, RPI rescinded the ban on beards and long hair.

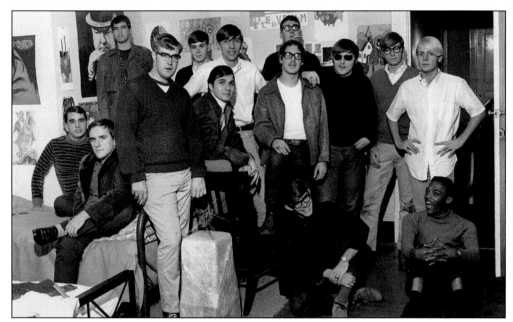

MEN'S DORMITORY, 1968. The men's dormitory at 928 Park Avenue was typical of student housing at RPI. From the 1930s through the 1960s, the school acquired former residences built at the turn of the last century and used them as either men's or women's dormitories. This building, the other houses on the block, and the Scottish Rite Temple were demolished in the late 1970s and replaced by the W. E. Singleton Center for the Performing Arts.

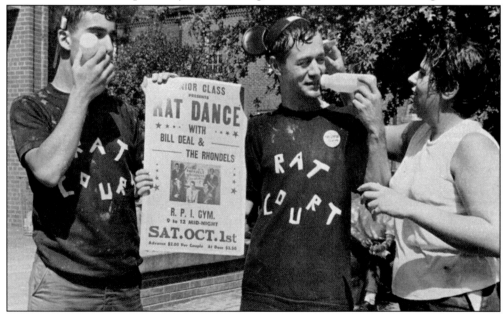

RAT WEEK, SHAFER COURT, 1967. Freshmen were at the mercy of the juniors during Rat Week, a tradition from the 1940s through the 1960s. Rituals included asking permission to enter the dining hall, reciting the honor code on demand, and wearing funny clothing. Violators were tried by the Rat Court and usually ended up on the losing end of one-sided food fights. On Friday, the freshmen turned the table on the juniors.

Six

CREATING A UNIVERSITY
1968–1978

Political, social, and cultural transformations reshaped the United States between the mid-1960s and the mid-1970s. Angry and vocal protests against existing social conditions polarized major cities across the country. Roars also emanated from the areas east and west of downtown Richmond, as the Richmond Professional Institute and the Medical College of Virginia gradually and slowly became parts of a new institution: Virginia Commonwealth University. In the face of difficulties and occasional outright opposition, the university continued to educate students, build new facilities, perform new medical procedures, and launch new programs and schools.

RPI and MCV had shared many resources over the previous 50 years. RPI's public health program had made use of MCV facilities and faculty from its inception. By the 1960s, MCV students were enrolling in English, history, statistics, and economics courses at RPI. The boards of the two schools had even approved a joint doctorate in clinical psychology. Still, the great transition into one institution would generate many difficulties.

In addition to the antiwar and civil rights protests that characterized many major universities during this period, unrest at VCU took on a peculiar cast. Administrators, faculty, and alumni at RPI and MCV debated the wisdom, speed, and methods of the proposed amalgamation. The process proved far from purely intellectual and claimed several administrative casualties. Still, a general commitment to creating a premiere learning and research environment prevailed. Ultimately the conflicts allowed the university to move forward toward a synthesis.

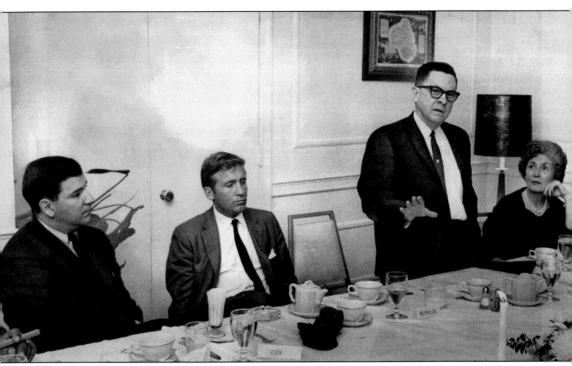

WAYNE COMMISSION MEETING, 1967. Following the 1965 report of the Bird Commission recommending the creation of a state university in Richmond, Edward A. Wayne Sr. (1903–1990), president of the Richmond Federal Reserve Bank, chaired the commission responsible for an implementation plan. The recommendation, supported by the governor and general assembly, was the creation of Virginia Commonwealth University. Wayne's vision for the school rejected a merger and proposed instead to create a completely new entity with RPI and MCV as its components. The commission's 1968 report stated that "an urban-oriented university is unique in that its basic philosophy concentrates on meeting the needs of an urban population living and working in an urban environment. The city is truly its living laboratory." Pictured from left to right are architect Frederic H. Cox Jr., delegate and future lieutenant governor J. Sargeant Reynolds (1936–1971), Wayne, and delegate Eleanor Sheppard (1907–1991). Wayne was named vice-rector of the first Board of Visitors, and VCU's Wayne Medal honors individuals who have made outstanding contributions or provided exemplary services to VCU. (Copyright *Richmond Times-Dispatch*, used with permission.)

RPI Social Work Graduate Students, 1967. A number of cooperative programs existed between RPI and MCV in the years before the merger. MCV students frequently took basic humanities and science courses at RPI or with RPI instructors who had adjunct appointments at the medical school. The students seen here gained practical experience by working in the social work department at MCV Hospitals as part of their graduate curriculum.

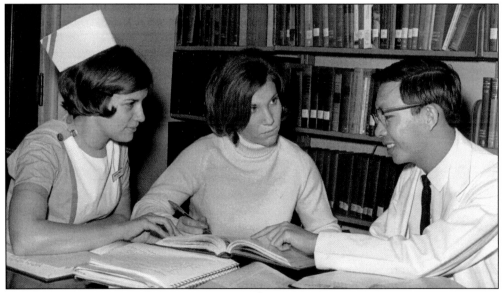

Students in the Tompkins-McCaw Library, 1968. MCV constructed its first library building in 1932. Since that time, the Tompkins-McCaw Library has remained a popular study spot for students. Named for five members of the Tompkins and McCaw families, it is the oldest and largest health sciences library in Virginia. The student seen at the far left appears in the new student nursing uniform designed by RPI alumna Marilyn Bevilaqua (1928–2005).

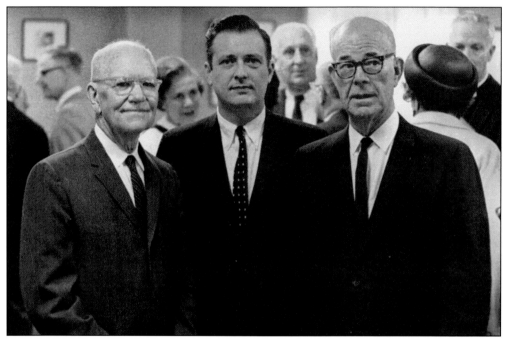

DEDICATION OF RHOADS HALL, MAY 14, 1968. The three leaders of RPI were together for the dedication of the first dormitory built for the Monroe Park Campus. Roland Nelson Jr. (born 1929), standing between Hibbs (left) and Oliver (right), headed the institution from 1967 to 1968. Nelson had been Oliver's chief administrative officer and retired as president when the union with MCV became official on July 1, 1968.

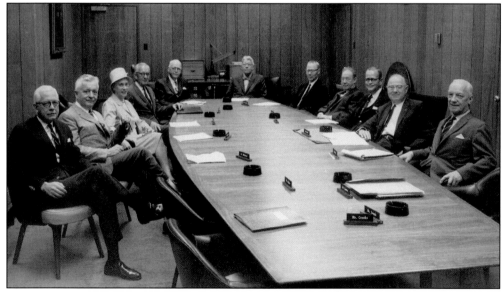

LAST OFFICIAL MEETING OF THE MCV BOARD OF VISITORS, JUNE 14, 1968. Members of the board from left to right were Richard A. Michaux, John H. Temple, Anne F. Mahoney, Byrnal M. Haley, S. S. Flythe, Buford Scott, Arthur L. Van Name Jr., Eppa Hunton IV, R. Blackwell Smith Jr. (MCV president), R. Reginald Rooke (chair), and John H. Heil (secretary). Board members William R. Cogar, C. Coleman McGehee, and Stuart Shumate are not pictured.

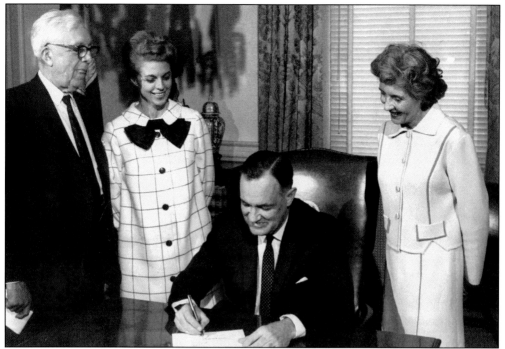

VCU Becomes a Reality, 1968. Three years of commissions, studies, and legislation culminated with Gov. Mills E. Godwin Jr. (1914–1999) signing the legislation creating Virginia Commonwealth University on March 1, 1968. State senator and MCV graduate Lloyd Bird (1894–1978) and delegate Eleanor Sheppard, standing at left, were the chief sponsors of this legislation. Pat Royal Perkinson, RPI alumna and Godwin's administrative assistant for public relations, stands at the right as the official witness.

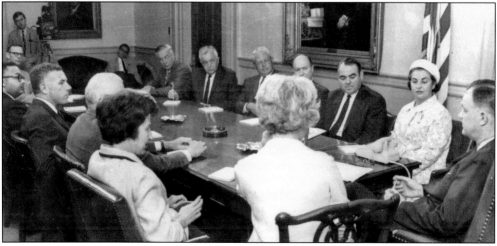

VCU's New Board, Governor Godwin's Office, April 23, 1968. Godwin hosted the first meeting of the new university's board, which included members from the former MCV and RPI Board of Visitors. At this meeting, Godwin appointed a three-member nominating committee to recommend a rector, vice rector, and secretary of the board. Virginius Dabney (1901–1995), historian and former editor of the *Richmond Times-Dispatch*, served as VCU's first rector. (Copyright *Richmond Times-Dispatch*, used with permission.)

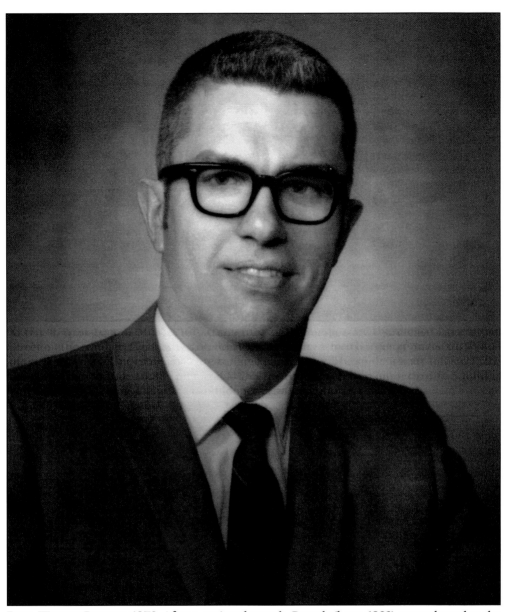

PRES. WARREN BRANDT, 1970. After a national search, Brandt (born 1923) was selected as the first president of Virginia Commonwealth University for his experience in Virginia higher education as the executive vice president of Virginia Polytechnic Institute and State University in Blacksburg, and he served from 1968 to 1974. Much of his time was spent attempting to unite two administrations with different facilities, processes, and rules into one unit. VCU briefly became the largest university in Virginia with 17,000 students, and both campuses expanded to accommodate the increasing demand, adding the James Branch Cabell Library, the School of Business Building, and Rhoads Hall on the Monroe Park Campus; and an addition to the Tompkins-McCaw Library and a large expansion of Sanger Hall on the MCV Campus. Thirty-two new degree programs and two new schools, the School of Allied Health Professions and the School of Community Services, were added.

AERIAL PHOTOGRAPH OF MCV, 1967. At the time of the merger, MCV stretched from Broad Street on the south to Leigh Street on the north with an eastern border at Interstate 95 and the western edge of the campus situated along Eighth Street. The student body totaled 1,592, the house staff included 1,883 physicians, and the college received more than $6.5 million in research funds in its last year as an independent institution.

AERIAL VIEW OF THE MONROE PARK CAMPUS, 1975. VCU's Monroe Park Campus was an integral part of Richmond's Fan District neighborhood, stretching west from Monroe Park to Harrison Street and north from Main to Franklin Streets. The campus served 15,600 students by the mid-1970s.

WILLIAM E. BLAKE JR. AND ALAN V. BRICELAND, 1973. Professors of history at the school since the mid-1960s, Blake (left) and Briceland took lead roles in establishing the university's governance system after it became VCU. Blake served as the first president of both the VCU Faculty Senate and the Virginia Faculty Senate. He retired in 1992. Briceland served long terms on both the faculty senate and the University Council before retiring in 2005.

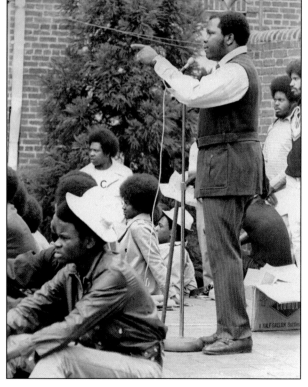

JIM ELAM ADDRESSING STUDENTS IN SHAFER COURT, 1970. Richmond native Jim Elam (born 1945) mounted his successful "The Art of the Possible" campaign to become the first African American president of student government in 1970. His platform included equitable treatment of all students, improved relations with Oregon Hill, student input on curriculum, more minority professors, and the establishment of an Afro-American Studies program. Elam graduated in 1973 with a degree in social work.

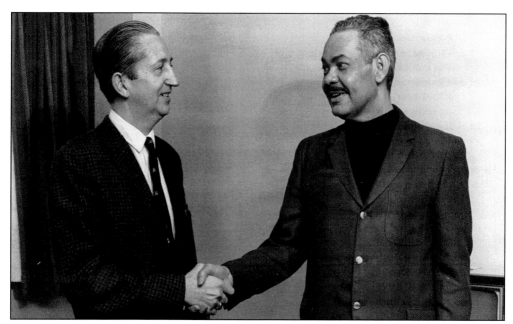

RALPH M. WARE JR. AND LOUIS B. RUSSELL, NOVEMBER 24, 1968. Ware (1922–1997), at left, first director of development for both MCV and VCU, assisted with media relations in the early years of the heart transplant program. Ware congratulated Russell (1925–1974), an industrial arts teacher from Indianapolis, Indiana, and MCV's second heart transplant recipient, following his August 24 operation. Russell lived longer than any previous heart transplant patient, bringing public recognition to the MCV Hospitals program.

KIDNEY TRANSPORT EQUIPMENT, 1970. Hume (center left) accepts the new kidney transport van from Ed E. Ratliff (center right) of the Richmond Community Relations Committee, Ford Motor Company. The Southeastern Regional Kidney Procurement Group used the specially designed van to transport donated kidneys from community hospitals to the clinical transplant centers. The United Network for Organ Sharing (UNOS) was an outgrowth of Southeastern Group organized by Hume.

THE VCU SYMBOL, 2005. In the fall of 1968, the university hired the New York marketing and design firm of Schechter and Luth, Inc., to develop an identifying symbol, colors, and names for the university's campuses. The firm released its findings in January 1969. The design of the VCU symbol provoked considerable controversy. Some commentators thought it too abstract; others believed that the design should have been created by the school's own art students. The design itself generated many interpretations. Some saw the tree of knowledge, others discerned the street pattern of the Fan District, and a few even claimed that it resembled a marijuana leaf. University officials stated that the symbol sought mainly to create something new that would unify the two former schools and emphasize the "bold new" character of VCU. In the late 1990s, the VCU symbol gradually became replaced with a contemporary font that displays the letters VCU and the words Virginia Commonwealth University. (Image courtesy of Ken Hopson.)

84

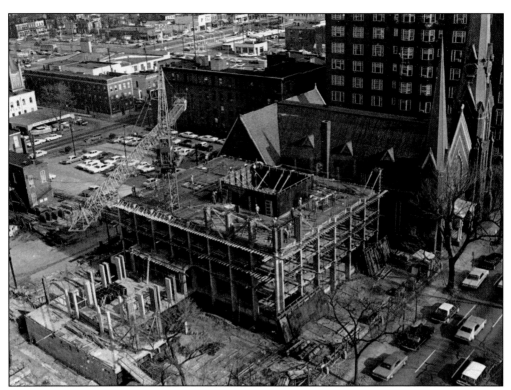

CONSTRUCTION OF RHOADS HALL, NOVEMBER 1966. Dedicated May 14, 1968, Rhoads Hall, 710 West Franklin Street, was built as a women's dormitory. The 18-story high-rise building is named for Webster S. Rhoads Jr. (1908–1967), a Richmond businessman and a member of the RPI Board of Visitors from 1962 until 1967. The Pace Memorial Methodist Church, on the right, built in 1886, was destroyed by fire in December 1966.

CONSTRUCTION OF PHASE III OF SANGER HALL, 1972. In one of its last official acts, the MCV Board of Visitors renamed the Medical Education Building in honor of former president William T. Sanger. The building was formally dedicated in April 1970. By that time, the medical school was in need of additional facilities, and the National Institutes of Health awarded VCU $6.3 million for a 120,000-square-foot addition to Sanger Hall.

ANTIWAR RALLY IN SHAFER COURT, MAY 5, 1970. Like college students across the nation, hundreds of VCU students rallied the day after four Kent State University students were shot by Ohio National Guardsmen. Theater students began the rally with a skit that ridiculed Americans who had wearied of hearing daily casualty reports on the Vietnam War. They offered their own "tricky Dick cure-all" for ignoring the tragedy of the war—red, white, and blue blindfolds. (Copyright *Richmond Times-Dispatch*, used with permission.)

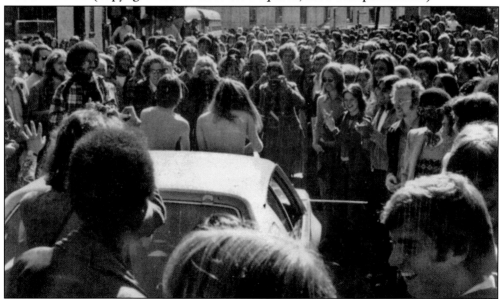

STREAKERS IN SHAFER COURT, MARCH 22, 1974. Two streakers drew a large crowd in Shafer Court five days after Richmond police arrested four night-time streakers for indecent exposure and 11 other students for disorderly conduct (two of whom were charged with inciting a riot). Students complained that the police used excessive force and over-reacted to the event. (Copyright *Richmond Times-Dispatch*, used with permission.)

86

TELEVISED INSTRUCTION IN THE SCHOOL OF DENTISTRY, 1970. The School of Dentistry began using educational television in January 1953. The camera could show intricate dental procedures to a large group of students at the same time. In 1969, the school became the first in the country to use color television for instruction.

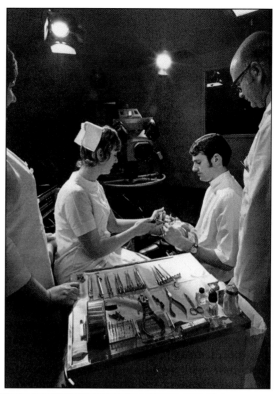

GROUNDBREAKING FOR NEW DENTAL SCHOOL BUILDING, 1967. On November 8, 1967, MCV held groundbreaking ceremonies for a second dental school building. In 1971, the university named the building for former dental school dean Harry Lyons (1900–1993), who served from 1951 until 1970. Participating in the ceremonies were, from left to right, Lyons, MCV president Smith, John W. Hughes, W. C. Henderson, and R. Reginald Rooke.

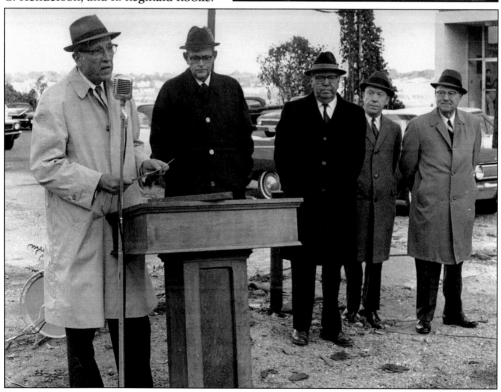

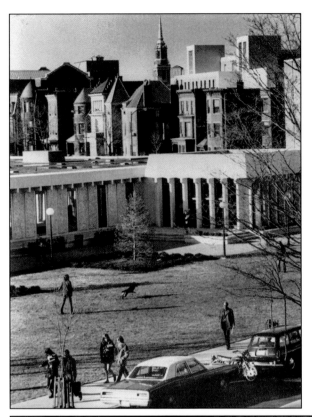

JAMES BRANCH CABELL LIBRARY, 1972 (TOP), AND JAMES BRANCH CABELL, C. 1935 (BOTTOM). Shortly after the creation of VCU, work began on a new university library designed by Lee, King, and Poole. Months after it opened in 1970, the legislature made a second commitment of funds, and the top three floors were added in 1975. English professor Maurice Duke worked with Margaret Cabell (1893–1983), widow of Richmond author James Branch Cabell (1879–1958), to obtain the author's extensive personal library for VCU. In 1920, the State of New York attempted to ban Cabell's 15th book, *Jurgen*, for pornography. Laced with erotic imagery, but very tame by contemporary standards, the book was cleared of the charges and became his best-selling work.

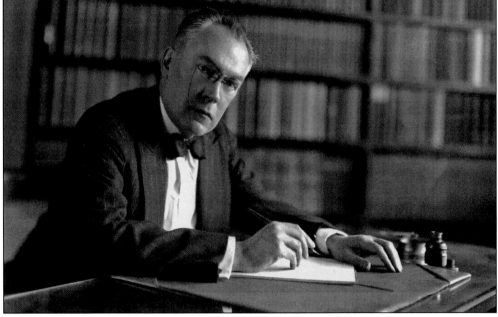

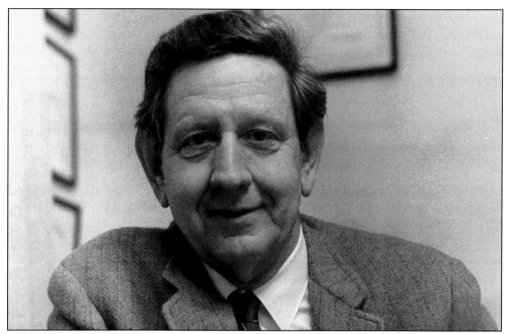

JOHN A. MAPP, c. 1970. Mapp (1913–2002), dean of the Evening College and Summer School from 1964 to 1978, is credited with increasing enrollment in these programs by introducing innovations such as classes on weekends and winter break intersessions. In 1984, he and Daniel T. Watts (1917–1994), former dean of the School of Basic Sciences, were the first recipients of the Presidential Medallion, which recognizes outstanding contributions to VCU by members of the university community.

VCU STUDENT TEACHER, c. 1970. Teacher education always played a central role at the institution, but a formal School of Education did not exist until 1964. The new school absorbed the elementary education and health and physical education departments and taught core education classes in programs that remained administratively in other schools, training future art, music, English, and vocational secondary school teachers.

89

INAUGURATION OF T. EDWARD TEMPLE, THE MOSQUE, DECEMBER 1975. Temple (1916–1977) succeeded Warren Brandt as VCU's second president, serving from 1975 until his sudden death. Temple learned the inner workings of the university while secretary for administration under Gov. A. Linwood Holton Jr. (born 1923), when he headed a 1972 committee that investigated inadequacies in MCV Hospitals. Temple joined the university as vice president for development and university relations in 1973 and chaired the three-man committee that briefly ran the school after Brandt's abrupt retirement in October 1974. Temple died of a heart attack just 15 months into his administration, only 3 months after his wife succumbed to a long illness. Before joining state government, he had been city manager for the Virginia cities of Danville and Hopewell. Temple's understanding of the Commonwealth led him to develop a "traveling road show" in an effort to interpret the school to the public, increasing enrollment and support throughout the state.

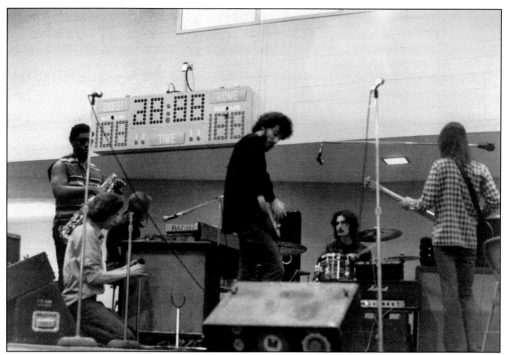

BRUCE SPRINGSTEEN SOUND CHECK, FEBRUARY 14, 1973. By the time Bruce Springsteen and the E Street Band played this 1973 show at VCU's Franklin Street Gym, opening up for Dan Hicks and His Hot Licks, Springsteen had played nearly 30 shows in Richmond, four of them at VCU. From left to right are Clarence Clemons, Danny Federici on keyboards, Springsteen, Vini Lopez on drums, and Garry Tallent. (Image courtesy of Jeff Crossan.)

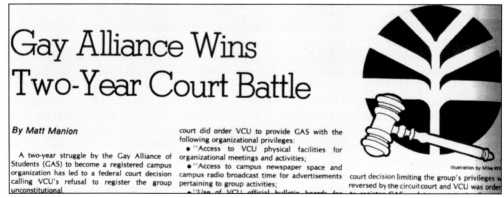

Gay Alliance Wins Two-Year Court Battle

By Matt Manion

A two-year struggle by the Gay Alliance of Students (GAS) to become a registered campus organization has led to a federal court decision calling VCU's refusal to register the group unconstitutional.

court did order VCU to provide GAS with the following organizational privileges:

● "Access to VCU physical facilities for organizational meetings and activities;
● "Access to campus newspaper space and campus radio broadcast time for advertisements pertaining to group activities;
● "Use of VCU official bulletin boards for

court decision limiting the group's privileges w reversed by the circuit court and VCU was order

Illustration by Mike Wil

STUDENTS WIN COURT BATTLE, *COMMONWEALTH TIMES*, NOVEMBER 1976. Organized in 1974, the Gay Alliance of Students was denied registration as a campus organization by the VCU Board of Visitors. The board later argued that the existence of the group would, among other things, "increase the opportunity for homosexual contacts." In November 1976, a Federal Appeals Court ordered VCU to give the group full recognition as an official student organization.

JAMES W. BLACK MUSIC CENTER, LATE 1970s. As residents moved from the Fan to the neighboring counties, many beautiful facilities remained behind as churches closed or followed their congregations. In 1977, VCU purchased the old Grace Street Baptist Church, a 1901 Gothic Revival building featuring a square bell tower and triple stained-glass windows. In 2005, VCU named it the James W. Black Music Center in honor of a prominent local jazz pianist.

SUZANNE HIRT INSTRUCTS PHYSICAL THERAPY STUDENTS, 1970. With funding from philanthropist Bernard Baruch (1870–1965), MCV established a physical therapy educational program as part of the Baruch Center for Physical Medicine in 1945. Suzanne Hirt (born 1913) served as chair of the physical therapy program for over 30 years beginning in the late 1940s. The first accredited physical therapy program in Virginia was one of the earliest baccalaureate programs in the country. Initially administered as an independent school, the program became a department within the School of Allied Health Professions in 1969.

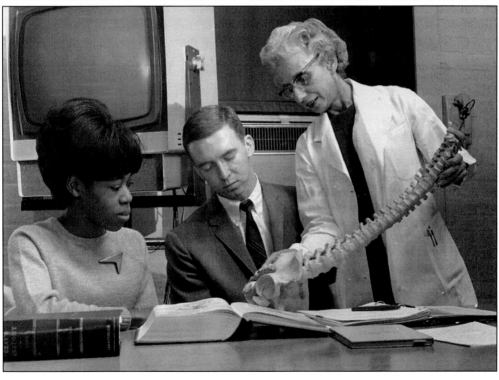

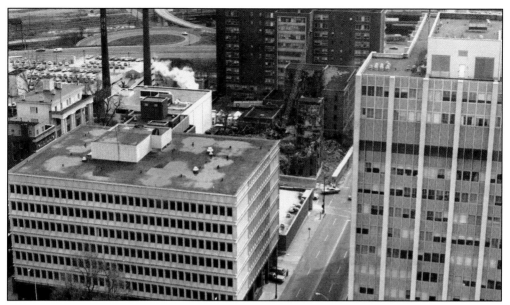

DEMOLITION OF HUNTON HALL AND ST. PHILIP HALL, 1977 (TOP), AND CONSTRUCTION SITE REPLACEMENT HOSPITAL, 1978 (BOTTOM). By 1965, MCV had formally desegregated its hospital complex. Most of the facilities were either out-of-date or in poor condition, and several faculty members appealed directly to Governor Holton for relief. He appointed Edward Temple to head a commission to investigate conditions at the MCV Hospitals. Both the commission's report and VCU's first self-study, undertaken at the time of the university's initial accreditation by the Southern Association of Colleges and Schools, found fault with the clinical facilities. The public criticism finally led to funding for a replacement hospital, and VCU secured the necessary bond package from the Commonwealth beginning in 1976. Two old dormitory facilities originally constructed during Sanger's tenure were razed to make way for the new structure at the northeast corner of Twelfth and Marshall Streets.

VCU Football Scrimmage, Early 1970s. RPI and VCU had a number of football clubs, some of which competed regularly against teams from D.C. colleges. Student newspaper editor Tom Robbins often defended the school when others ridiculed the lack of intercollegiate football, such as in 1958 when a radio sportscaster stated that colleges without football teams served as potential breeding grounds for communists.

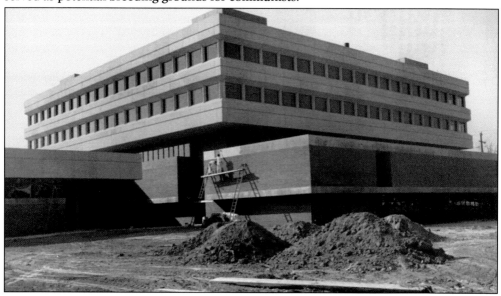

School of Business Building, c. 1972. Hibbs bucked the anti-business populism of the Depression and used federal funds available to the School of Store Service to create core business classes starting in 1939. The School of Business was created in 1946 and renamed Business Administration in 1952. The badly needed business building opened in 1972 to lukewarm reviews, with many considering it too "monolithic." Its successor on the Monroe Park Campus Addition will open in 2007.

Seven

Virginia's Urban University

1978–1990

The intense changes that dominated the brief tenure of VCU's first two presidents contrasted dramatically with the feeling of stability under President Ackell. Growth and facilities expansion continued to be a hallmark of the university, but VCU began to feel more like a college campus than a set of disparate buildings and programs. It also took on more characteristics of a research university, primarily through the infusion of National Institutes of Health dollars.

The vitality and growth on both campuses appeared in stark juxtaposition to the rapid deterioration of the urban areas that separated them. Suburbanization culminated during this period in the loss of Broad Street's retail core, decimating the city of Richmond's tax base and providing opportunities for VCU to expand into long-coveted neighboring areas. After a decade of looking outward toward the Vietnam War and Watergate, the campus media turned its attention inward, concentrating more on university affairs and particularly on the VCU administration. National trends of the 1980s also influenced campus life as ROTC programs began, sororities and fraternities grew, and athletics achieved a higher profile and better funding.

Diversity characterized campus life. VCU attracted students from a broad range of racial, ethnic, and class backgrounds. A strong mixture of full- and part-time students, as well as residents and commuters, contributed to the hectic campus atmosphere. Whether a student enrolled in one non-credit evening school course or pursued a Ph.D. in microbiology, VCU sought to "accommodate them with determination."

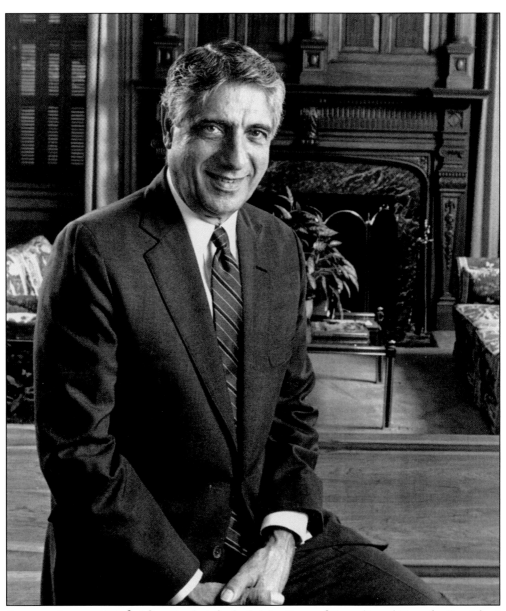

EDMUND ACKELL, 1986. After the brief administrations of Brandt and Temple, President Ackell's (born 1925) 12-year tenure begun in February 1978 supplied VCU with its first stable leadership. He began his career as professor of dentistry and served as the vice president for Health Affairs and special assistant for Governmental Affairs at the University of Southern California prior to being selected to lead VCU from over 200 applicants. The university had grown to more than 20,000 students, and Ackell directed a vigorous physical expansion while reorganizing and streamlining the strained administrative structures, a process not always met with enthusiasm among the faculty. This relationship was further weakened by the institution of an annual review of all faculty, including those with tenure. His administration also had an extremely contentious relationship with the student media. Ackell directed a new emphasis on intercollegiate athletics, increasing the number of sports, constructing new facilities, and purchasing new equipment.

GERALD HENDERSON, 1978. The 1977–1978 VCU men's basketball team, led by senior guard Henderson (born 1956), finished with a 24-5 record, earning the Rams their first postseason appearance and national exposure. The Richmond-born Henderson finished his four-year career with more than 1,500 points. He was drafted by the San Antonio Spurs and enjoyed a 13-year professional career, winning four NBA championships with Boston and Detroit. (Image courtesy of VCU Athletics.)

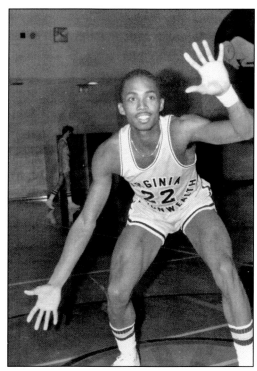

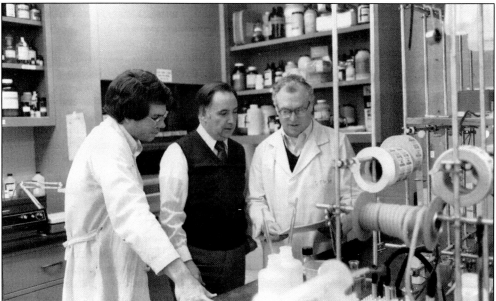

BASIC HEALTH SCIENCES FACULTY IN SANGER HALL LAB, 1982. Biochemistry faculty member Marino Martinez-Carrion (center) discusses a research project with his School of Basic Health Sciences colleagues Sam Hopkins (left) and Verne G. Schirch (right). MCV organized the School of Basic Health Sciences in 1966 to serve as the administrative home for departments such as biochemistry, microbiology, and pharmacology. Daniel T. Watts led the school during its formative years and recruited many outstanding research scientists. Basic Health Sciences merged with the School of Medicine in 1993.

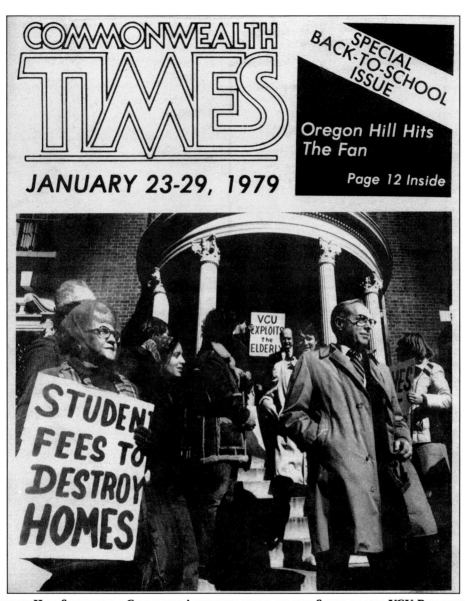

COMMONWEALTH TIMES

SPECIAL BACK-TO-SCHOOL ISSUE

Oregon Hill Hits The Fan

Page 12 Inside

JANUARY 23-29, 1979

STUDENT FEES TO DESTROY HOMES

VCU EXPLOITS The ELDERLY

OREGON HILL SUPPORTERS CONFRONT ADMINISTRATORS ON THE STEPS OF THE VCU PRESIDENT'S HOUSE, *COMMONWEALTH TIMES*, JANUARY 1979. For over 20 years, a battle existed between VCU and the residents and supporters of Oregon Hill, a small working-class neighborhood located just south of the university. Since its inception, VCU had expressed interest in acquiring large sections of the neighborhood to build athletic facilities and dormitories. In January 1979, when VCU Board of Visitors rector Wyndham Blanton (seen here with glasses) and President Ackell announced to the press that the university had decided to go ahead with its plans, residents picketed outside, unable to get an audience with decision makers. Groups like the Oregon Hill Home Improvement Council helped the neighborhood thwart plans that would have demolished over 100 homes. Soon after Eugene P. Trani (born 1939) arrived in 1990, he made a commitment to Oregon Hill residents not to encroach upon their neighborhood. Expansion at VCU did occur in the 1990s, but the land acquired by the university was located north along Broad Street.

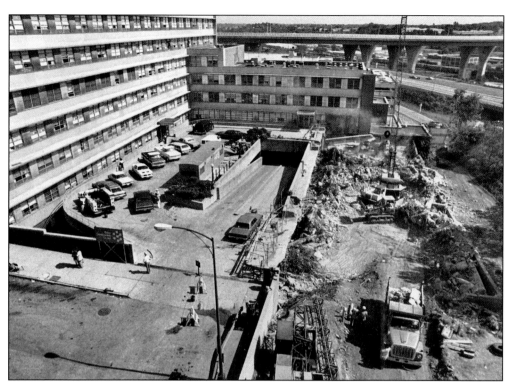

CONSTRUCTION OF MASSEY CANCER CENTER, 1981. VCU formally established a cancer center in October 1974 to coordinate patient care, research, and educational initiatives. A year later, it was added to the national network of cancer centers and was the first National Cancer Institute (NCI)–designated cancer center in Virginia. In May 1983, VCU named the center in honor of William E. Massey Sr. and family.

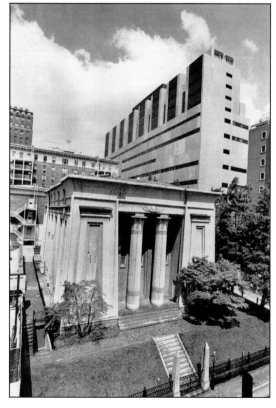

MAIN HOSPITAL, 1984. In June 1982, VCU opened its first new hospital facility in almost 30 years. The 12-story, 536-bed facility cost over $65 million and included one of the largest emergency departments in the country. From the struggle to secure funding to the difficulty in obtaining pre-cast concrete panels for the exterior of the building, the entire project had been a decade-long ordeal for the university.

99

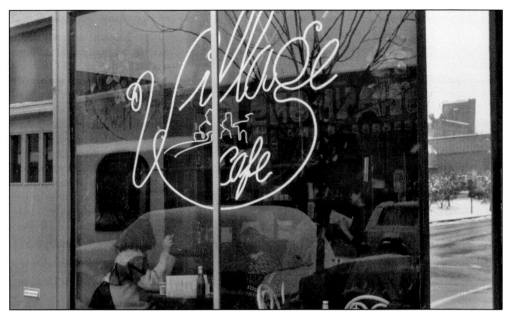

THE VILLAGE CAFÉ, 1989. The Village Café is considered the most bohemian of all VCU area restaurants and bars. Described by writer Tom Robbins as a "clubhouse for most of the intelligent misfits in Richmond," the restaurant has been catering to an assortment of non-conformists since the late 1950s. In 1992, it moved across the street from its first location at 939 West Grace Street.

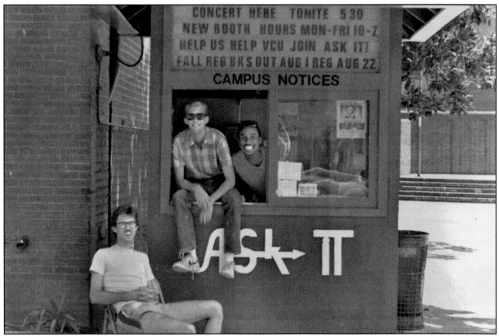

ASK IT BOOTH, SHAFER COURT, c. 1980. During the 1970s and 1980s, the Ask It Booth, located to the right of the Shafer Street Playhouse, was a common sight on the Monroe Park Campus. Students who manned the booth provided directions to campus buildings and information on school topics and campus activities.

SMITH BUILDING, 1985. In 1972, the American Council on Pharmaceutical Education warned VCU that the School of Pharmacy was in jeopardy of losing its accreditation unless new facilities were secured. VCU finally broke ground at the southwest corner of Clay and Twelfth Streets for a new pharmacy building named in honor of R. Blackwell Smith Jr. in 1981. Mr. and Mrs. E. Claiborne Robins Sr. contributed $1.2 million to the $12 million construction costs.

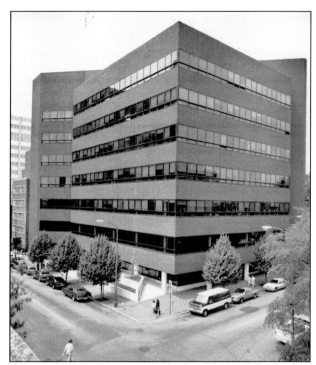

MCV CAMPUS STUDENT GOVERNMENT ASSOCIATION, 1985. MCV students organized a student government early in the 20th century, shortly after adopting an honor code. Since that time, students have continued to take an active role in governance and the honor system. From left to right are officers for the 1984–1985 academic year: Mark Berry, treasurer; Amanda D. Williams, secretary; William E. Crutchfield II, president; Kenneth Copeland, parking; and Morgan E. Norris, yearbook editor.

STUDENTS OUTSIDE THE JONAH L. LARRICK STUDENT CENTER, 1986. The student center, built in 1961 as the Virginia Civil War Centennial Center, serves as a cafeteria and social center on the MCV campus. It was named for Larrick (1897–1977), the former YMCA director at MCV. By the mid-1980s, enrollment had grown to just over 2,600 students, including an increasing number of women in all professional and graduate programs.

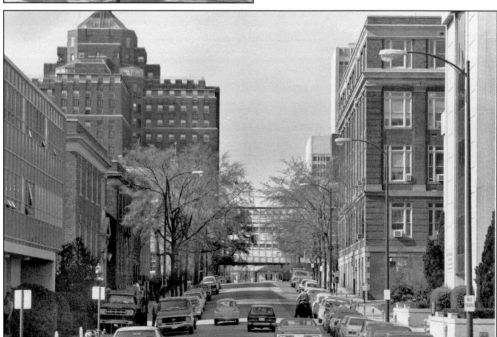

MCV CAMPUS FROM TWELFTH STREET, 1978. With the opening of Main Hospital in 1982, Twelfth Street became one of the major arteries on the MCV campus. Traffic patterns on the busy street have been adjusted over the years to accommodate emergency vehicles, the university shuttle bus system, and new construction projects. Those traveling south on Twelfth enjoyed a view from the northern edge of campus to the governor's mansion on Capitol Square.

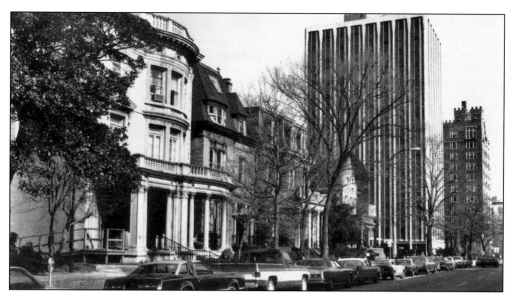

THE 800 BLOCK OF WEST FRANKLIN STREET, *c.* **1980.** Some of the most architecturally significant buildings of 19th- and 20th-century Richmond are located on, or adjacent to, both campuses of VCU. On the Monroe Park Campus, these include many of the historic houses along the 800 and 900 blocks of West Franklin Street. Charles Brownell, head of the Architectural History Program at VCU since 1992, has called the street an "open air museum of architectural history."

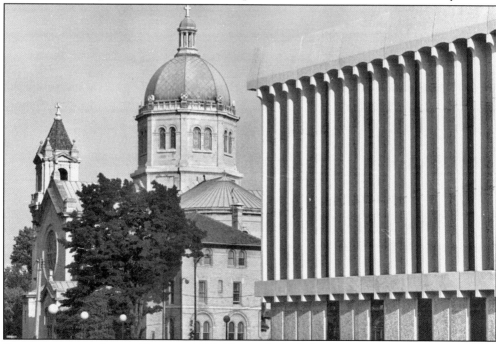

CATHEDRAL OF THE SACRED HEART, *c.* **1980.** The Cathedral of the Sacred Heart, located between Monroe Park and Cabell Library, is a familiar sight to students. Workers laid the cornerstone of this Virginia marble and Indiana limestone building in 1903, and the consecration occurred on Thanksgiving Day, 1906. The cathedral, home of the Richmond Catholic Diocese, is considered Virginia's finest ecclesiastical example of the Italian Renaissance Revival style.

STREET VENDORS, 1986. As the MCV campus expanded, options for lunch became scarce. In the 1980s, a number of street vendors found that the 1100 block of Marshall Street was a lucrative spot to set up a cart. Today students, staff, and faculty on the MCV campus can choose between pasta, wraps, and Thai or Indian cuisine, as well as the old-fashioned hot dog.

MATCH DAY, 1986. Each year in March, medical students learn where they will begin their residency programs following graduation. The National Resident Matching Program (NRMP) was established in 1952 to provide a uniform starting date for residency training. Scott Agran, VCU class of 1986, learned he would head to the University of California Irving Veterans Administration Hospital on Match Day 1986.

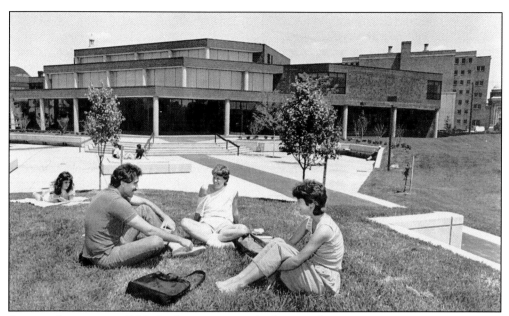

STUDENT COMMONS, c. 1985. Student activities relied on small quarters in VCU's many converted houses to host their meetings and events until the Student Commons opened on the 900 block of Floyd Avenue in January 1984, with additions in 1993 and 2004. The commons has an auditorium, theater, meeting rooms, game room, career center, computer sales and repair shop, dining options, and a number of administrative offices serving student needs.

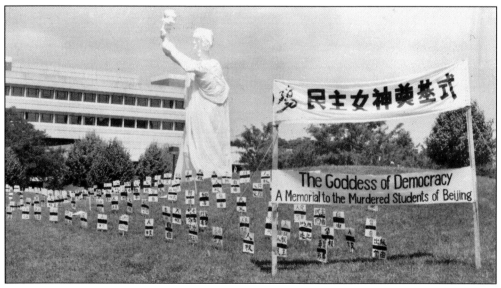

"GODDESS OF DEMOCRACY" MEMORIAL, STUDENT COMMONS LAWN, JUNE 1989. Days before the Tiananmen Square massacre killed 3,000 Chinese students, a 33-and-a-half-foot-tall "Goddess of Democracy" was erected in the square by the students to symbolize the cause of their protest. Weeks after the massacre, VCU art students created a "Goddess of Democracy" memorial to the murdered students with the assistance of local artists, the Chinese community of Richmond, and area merchants who donated materials.

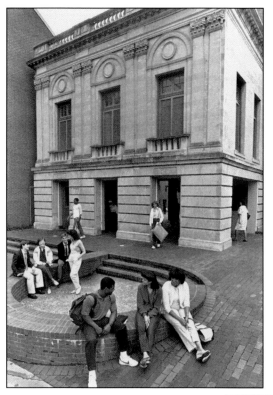

GLADDING RESIDENCE CENTER, LATE 1980s. The rise in enrollment triggered by the baby boom generation overflowed existing university housing, leaving hundreds of students in VCU-leased space six miles from campus until this apartment-style dormitory opened in 1979. The center was named after Jane Bell Gladding (1909–1997), professor of chemistry and dean of women. Students enter through the carefully preserved limestone façade of the Branch Public Baths that stood previously on this site.

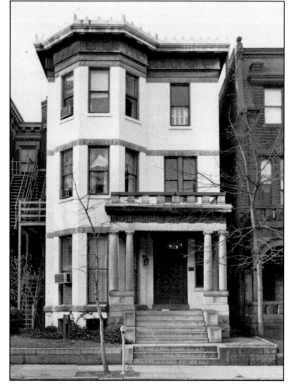

THE YOUNGER-CRENSHAW HOUSE, 1980s. The first meeting of the Equal Suffrage League, which led the women's suffrage movement in Virginia, took place on November 20, 1909, in the home of Anne Clay Crenshaw (1859–1945) at 919 West Franklin Street. RPI purchased the building in the 1960s. Fittingly, the home now houses VCU's Center for Public Policy.

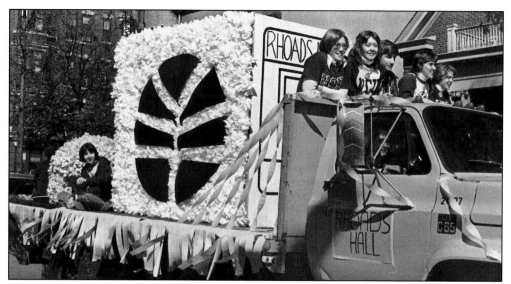

HOMECOMING FLOAT, 1976. There were several unsuccessful student-organized attempts to establish a homecoming tradition centered around a VCU Football Club game. A university-organized annual homecoming festival during basketball season began in February 2002.

VCU DANCE, 2004. Dance instruction moved from the Health and Physical Education Department to the School of the Arts and began offering a B.F.A. degree in 1980. The program moved in 1982 to the Dance Center, a converted elementary school built in 1910 with floor-to-ceiling windows. (Image courtesy of VCU Dance and Bruce Berryhill.)

NORTH HOSPITAL REOPENING, 1986. VCU renovated the North Hospital in 1986 to modernize its entire hospital complex. For the first time since World War II, patients would be housed in facilities less than five years old. Participating in the ceremony were, from left to right, Carl Fischer, executive director MCV Hospitals; Ackell; William Berry, VCU Board of Visitors; Jeannie Baliles, first lady of Virginia; Roy West, mayor of the city of Richmond, and Alastair Connell, vice president for health sciences.

ALPHA KAPPA LAMBDA FRATERNITY HOUSE, 1990. Considered undemocratic by RPI administrators, fraternities and sororities were banned by the school in the late 1930s. Social fraternities and sororities began to reappear on the Monroe Park Campus in 1970. The VCU chapter of the Alpha Kappa Lambda fraternity, located at 1115 West Main Street, was organized at VCU in 1985. Delta Sigma Theta is the oldest Greek social organization on campus, founded at VCU on May 14, 1970.

ALPHA PHI ALPHA IN STEPPING COMPETITION, STUDENT COMMONS, 1989. Stepping, a cross between choreography and military-style precision drill, and stepping competitions are a tradition among African American fraternities across the United States. In 2005, VCU had 12 fraternities and 12 sororities on the Monroe Park Campus.

FASHION SHOW, 2005. The Department of Fashion Design and Merchandising's annual Fashion Show exhibits high-quality and innovative student work. Founded in 1936, RPI's Department of Costume Design and Fashion was led by Hazel Mundy until her retirement in 1965. The department's graduates work in a diversity of fashion spheres from major retail outlets to New York design firms. (Image courtesy of VCU Fashion Design and Merchandising and Jay Paul.)

WILLIAM H. TURPIN AND MASS COMMUNICATION STUDENTS, 1978. Journalism training began in 1946 as a program in the English program before becoming its own department four years later. In 1972, it began offering specializations in news writing, broadcast news, public relations, and advertising and evolved into the School of Mass Communications by 1982. Turpin, who died in 2002 at the age of 72, helped establish the graduate program in mass communications.

WRESTLING MATCH, C. 1980. VCU currently competes in 14 NCAA sports. At various times in its history, it has competed against other colleges in wrestling, football, crew, swimming and diving, weight lifting, judo, and water polo. RPI and VCU competed in a number of conferences composed of Virginia schools before joining the Sun Belt Conference in 1978, moving to the Metro Conference in 1991, and then to the Colonial Athletic Association in 1995.

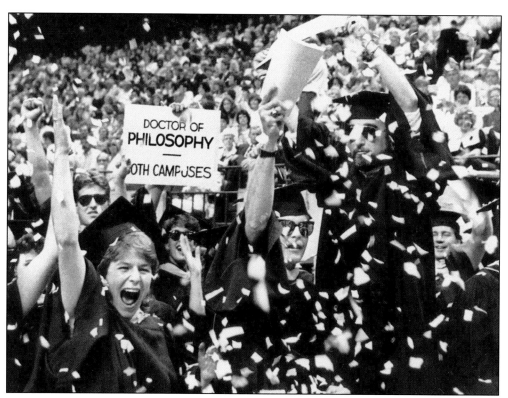

VCU Commencement, Richmond Coliseum, mid-1980s. By 1990, VCU had an enrollment of 21,000. The number graduating yearly had reached just over 3,000 students in associate's, baccalaureate, master's, first-professional, and doctoral degrees, representing 11 schools and one college and a total of 141 degree programs. The large commencement gatherings were regularly held at the Richmond Coliseum not far from the MCV campus. The sign the student is holding reads "Doctor of Philosophy—Both Campuses."

Sesquicentennial History of VCU, 1987. After the creation of VCU, the Board of Visitors selected the MCV creation year of 1838 as the founding date for the university. As the year 1988 approached, the university began planning for a major sesquicentennial celebration. Ackell contracted with historian Virginius Dabney to write the first history of VCU, which was published by the University Press of Virginia in 1987.

VIRGINIA
COMMONWEALTH
UNIVERSITY
A Sesquicentennial History ✦ *Virginius Dabney*

CONCERT IN SHAFER COURT (TOP) AND RED HOT CHILI PEPPERS, APRIL 14, 1989 (BOTTOM). Friday night free rock concerts in the courtyard of Shafer Court organized by the student concert committee always drew good crowds. The image above shows the singer for Rosebud, the Richmond-area band that opened the show that night for the Red Hot Chili Peppers. The beer truck in the top right was also a consistent concert draw. The image below is of the Red Hot Chili Peppers, one of hundreds of local and nationally known rock bands and musical acts who performed on the brick stage in Shafer Court during its existence from 1960 to 2002. From left to right are John Frusciante, Anthony Kiedis, and Flea.

Eight

EUGENE P. TRANI AND THE EXPANSION OF VCU *1990–2005*

Pres. Eugene P. Trani moved VCU into the 21st century by advocating entrepreneurialism, community involvement, and strategic planning as the key components to academic growth. Before long, numerous programs ranked in the top 20 nationally; many School of the Arts and School of Allied Health Professions programs had reached the top 10; and, by 2005, the Departments of Sculpture, Nurse Anesthesia, and the Adcenter ranked number one.

VCU also began several global initiatives. The VCU-Qatar School provided new educational and professional opportunities for Middle Eastern women, just as the Richmond School of Social Economy once served the women of Virginia. VCU also assumed center stage in Stockholm, Sweden, when John Fenn accepted his 2002 Nobel Prize for Chemistry. VCU annually hosts the world premieres of some of the best in European cinema at its French Film Festival.

The university's extended reach has coincided with a deepening local influence. VCU became partners with the neighboring Carver community as the university expanded northward. The privately funded engineering building represented a quantum leap in support from the business community. The Biotechnology Park is an incubator location for companies engaged in biological and forensic research. Upgrades to the hospital complex and Massey Cancer Center increased the level of health care available to the region.

With the development of the VCU 2020 Plan to guide it, Virginia Commonwealth University continues to explore new avenues of growth and involvement in the local, national, international, and research communities.

EUGENE P. TRANI, *c.* **1995.** After a national search to find a successor to Ackell, President Trani came to VCU from his position as vice president of academic affairs for the 15-institution University of Wisconsin system with 25 years of experience as a historian and administrator in Midwestern public institutions. In his 15 years at VCU, he has spearheaded the infusion of over $1 billion into the institution's infrastructure, the majority in support of the sciences, engineering, and patient care. He has had extremely strong and friendly relations with state and local governments and the local business community, serving as chairman of the Metropolitan Richmond Chamber of Commerce in the late 1990s. In his first year, he instituted the Community Service Associates Program to pair faculty with community organizations in need of their expertise, and he has established VCU as a case study for the impact of higher education in the revitalization of our nation's cities.

VIRGINIA GOVERNOR DOUG WILDER AND BILL CLINTON VISIT MCV HOSPITALS, OCTOBER 16, 1992. Democratic presidential nominee Clinton (born 1946) visited the Bone Marrow Transplant Program on the day after the second debate of the 1992 presidential campaign, held in Richmond. Wilder (born 1931) accompanied the future president and future senator Hillary Rodham Clinton (born 1947) to the MCV campus after participating in a large rally in Capitol Square that morning.

MIKHAIL GORBACHEV SPEAKS AT THE STUDENT COMMONS, APRIL 1993. Former USSR president Gorbachev (born 1931) visited Richmond as part of a speaking tour of Virginia and answered a number of questions concerning *glasnost* and *perestroika*, some from Russian VCU students. Trani, seated, has written extensively on United States–Russian relations and taught U.S. history at Moscow State University in 1981. Raisa Gorbachev briefly fell ill during the visit and was treated at MCV Hospitals for fatigue.

GRACE HARRIS, 1990s. Grace Harris applied for admission to RPI's School of Social Work graduate program in 1954, the same year that the Supreme Court declared segregation unconstitutional in *Brown v. Board of Education*. Against the backdrop of Virginia's campaign of "Massive Resistance," Harris was denied admission because of her race, and the Commonwealth paid for her to attend Boston University instead. After attending Boston University for two years, she transferred to RPI and received her Master's of Social Work in 1960. This was the start of a brilliant career in academia in which she received her Ph.D. from the University of Virginia; became one of the first three African American faculty members hired by RPI in 1967; was named dean of the School of Social Work in 1982; became provost of the university in 1993; and briefly served as interim president of Virginia Commonwealth University for part of 1995. Harris retired from VCU as provost in 1999 after 32 years of university service and continues to serve as a faculty leader of the Grace E. Harris Leadership Institute.

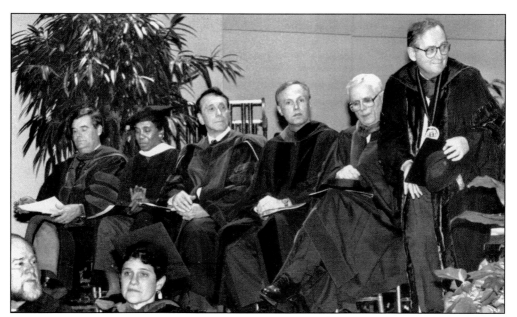

CONVOCATION, PERFORMING ARTS CENTER, FEBRUARY 9, 1994. Convocations had been held at both campuses prior to Ackell reviving the tradition in 1982. The VCU Convocation takes place annually and recognizes four distinguished faculty for outstanding accomplishments in the areas of teaching, scholarship, service, and overall excellence. President Trani, on the right, stands to take the podium.

DAVID BALDACCI, JAMES BRANCH CABELL LECTURER, SCHOOL OF BUSINESS AUDITORIUM, 1997. VCU alumnus Baldacci practiced law for nine years before becoming the author of 10 *New York Times* bestsellers as well as a popular series of children's books. The Northern Virginia resident has been a member of the VCU Board of Visitors since 2001 and is active with a number of charitable organizations.

L. Douglas Wilder Lectures to VCU Students, 1996. Wilder, the first popularly elected African American governor in the United States, currently serves as a distinguished professor in VCU's L. Douglas Wilder School of Government and Public Affairs. As Virginia's governor from 1990 to 1994, he guided the Commonwealth through a major budget shortfall while demonstrating his commitment to high standards of government practice. In 2004, he became the first mayor of Richmond elected at large in six decades. The School of Government and Public Affairs brings together faculty from multiple humanities and sciences disciplines. In March 1996, Wilder spoke to MCV campus students, including those in health administration, on health policy and politics. In 1949, MCV established a graduate program in hospital administration, one of the first in the United States. Initially a certificate program, it evolved into a master's degree curriculum by 1955. The program began as an independent school at MCV but was folded into the newly organized School of Allied Health Professions following the creation of VCU.

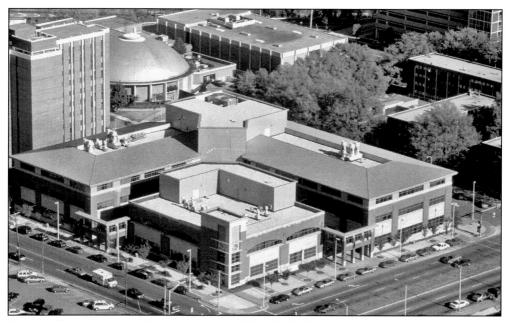

VIRGINIA BIOTECHNOLOGY RESEARCH PARK, 1998. Under President Trani's leadership, serious planning for a research park started in 1992, when the university, the City of Richmond, and the Commonwealth of Virginia formed a partnership. By July 1993, the Virginia Biotechnology Research Park Authority was operating as a nonprofit corporation. The first facilities in the park, located at the northern edge of the MCV campus, opened in December 1995. (Image courtesy of VCU Creative Services.)

EGYPTIAN BUILDING AND KONTOS MEDICAL SCIENCES BUILDING, 2003. Following the demolition of Randolph-Minor Hall, the Egyptian Building and the Medical Sciences Building (MSB) could be seen by those approaching from the east. MSB, a modern medical research facility constructed on the former sites of the Dooley and St. Philip Hospitals, was named for former School of Medicine dean and vice president for health sciences Hermes A. Kontos (born 1933) in March 2003. (Image courtesy of VCU Creative Services.)

MARIA-ELENA CALLE, 2001. Women's college athletics experienced a resurgence nationally after Congress passed Title IX legislation in 1972. Ecuadorian runner Calle re-wrote the VCU cross-country record books on her way to being named All-American six times in different events over her career from 1996 to 2001. Majoring in psychology and occupational therapy, Calle rebounded from a serious injury her sophomore year and competed in 10 NCAA nationals. (Image courtesy of VCU Athletics.)

WHITE COAT CEREMONY, 1997. Many medical schools hold white coat ceremonies to mark the start of a student's medical education. At VCU, the annual tradition began in 1996. Senior faculty help students into their white coats and listen while the new medical class recites the Hippocratic Oath. The Schools of Dentistry and Pharmacy hold similar ceremonies for their students. Walter Lawrence helps Troy Mitchell with his white coat while Hugo Seibel watches.

ENGINEERING BUILDING (TOP) AND CLEAN ROOM, 1999 (BOTTOM). VCU's engineering building was completed in 1998, two years after the founding of the School of Engineering. President Trani established the school, one of his major initiatives in the 1990s, as part of a public-private partnership with the VCU School of Engineering Foundation. The main classroom building and the adjacent Kenneth and Dianne Harris Wright Virginia Microelectronics Center (VMC) comprise 147,000 square feet and were built at a cost of $42 million. The VMC is a state-of-the-art education and research center featuring 7,500 square feet of clean room space for the fabrication of microelectronic chips, biochips, and micro electromechanical systems. Phase II of the School of Engineering is under construction on the Monroe Park Campus Addition and will be open in 2007. (Images courtesy of VCU Creative Services.)

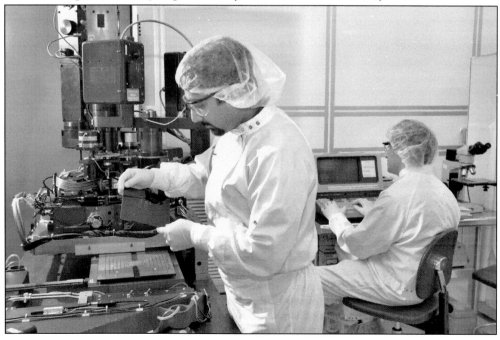

CELEBRATION FOLLOWING FIRST BASKETBALL GAME AT THE SIEGEL CENTER, NOVEMBER 19, 1999. VCU hosted the Louisville Cardinals in the first game at the Stuart C. Siegel Center and rallied to win 79-74 after trailing by 18 points at halftime, prompting the sell-out crowd to storm the court to celebrate with Rams players and coaches. The Siegel Center includes the 7,500-seat Alltel Pavilion, workout facilities for students, and conference rooms. (Image courtesy of VCU Athletics.)

CELINE #2 AND *CELINE #3* FROM *IN PEACE AND HARMONY: CARVER PORTRAITS,* **2004.** The Carver-VCU Partnership has established a community center, put student teachers in Carver Elementary School, sponsored an annual health and housing fair, worked with neighborhood residents to document their history, and extended VCU police patrols into the area. Artist Mary Ewald and the Visual Arts Center exhibited images of Carver children in a public art display. (Image courtesy of Visual Arts Center. Regula Franz, photographer.)

1999 BY DAVID FREED, 1999.
With an extensive permanent
collection, the Anderson
Gallery has become one of
the most important venues
of contemporary art in the
Southeast. In addition to the
annual M.F.A. thesis exhibition,
the gallery hosts exhibitions by
local, national, and international
artists. Printmaker Freed (born
1936), a Fulbright Scholar from
Iowa before starting his career
at VCU in 1966, was showcased
at the gallery in a 2001
retrospective. (Image courtesy
of David Freed.)

David Freed *Printmaker*

VCU-QATAR, 2004. In 1997, the Qatar Foundation and VCU School of the Arts collaborated to open the School of Design Arts in the Middle Eastern country's capital city of Doha. The Qatar Foundation has developed educational facilities in the region since 1995. The curriculum combines contemporary approaches to design adapted to the cultures of the region with degrees in communication arts and design, fashion design and merchandising, and interior design. (Image courtesy of VCU Creative Services.)

VCU LIFE SCIENCES, 2004. The four-story tall "Geneman" hangs on the Eugene P. and Lois E. Trani Center for Life Sciences. Drawing heavily on, and contributing to, the university's medical, biological, chemical, and engineering research, VCU Life Sciences offers undergraduate and graduate programs in environmental studies, bioinformatics, and a new Ph.D. in integrative life sciences. (Image courtesy of VCU Creative Services.)

GATEWAY BUILDING, 2002. President Trani led the move to secure independent authority for MCV Hospitals, which ultimately evolved into the VCU Health System by July 2000. Revenue bonds were approved in 1999 to construct this $59-million, nine-story building to serve as the entrance to MCV Hospitals. (Image courtesy of VCU Creative Services.)

STUDENT WITH LAPTOP, STUDENT COMMONS PLAZA, 2005. All incoming VCU students have been required to have personal computers since 2000, and it is the rare student who does not have a class taking advantage of the Blackboard course management system. Portable devices of all sorts have become more affordable and popular, and wireless internet access is quickly covering both campuses. (Image courtesy of Ken Hopson.)

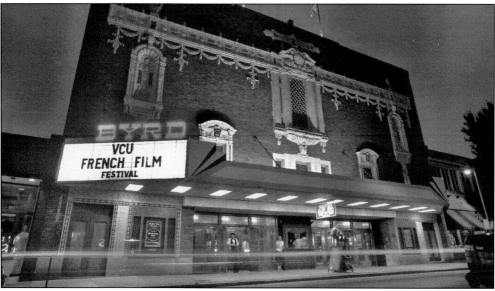

FRENCH FILM FESTIVAL AT THE BYRD THEATRE, 2005. VCU brings a stunning array of French feature films, shorts, and documentaries annually to the historic Byrd Theatre, built in 1928. Peter Kirkpatrick of the VCU School of World Studies and Françoise Ravaux-Kirkpatrick of the University of Richmond have produced the festival since 1993, for which they were decorated with France's highest arts honor, the Chevaliers de l'Ordre des Arts et des Lettres, in 2004. (Image courtesy of VCU Creative Services.)

Gov. Mark Warner Signs Bill, 2004. Six VCU Social Work students working under Robert Schneider shepherded two bills to prevent child abuse and sexual violence through the Virginia General Assembly. VCU graduate degrees in social work, first offered in 1927, are available to both Richmond and Northern Virginia. (Image courtesy of Commonwealth of Virginia's Governor's Office. Michaele White, photographer.)

Nobel Laureate John B. Fenn, 2002. Stockholm, Sweden, shined a spotlight on VCU's extensive research enterprise when research professor John B. Fenn won the 2002 Nobel Prize in Chemistry. Fenn spent much of his career at Princeton and Yale before moving to VCU in 1993. His research was in the field of mass spectrometry, creating a system to measure the mass of large biological protein molecules with unprecedented accuracy. (Image courtesy of VCU Creative Services.)

SHAFER COURT FROM THE TOP OF THE JAMES BRANCH CABELL LIBRARY, 2005. The 200 block of North Shafer Street has been the main campus thoroughfare since 1930. Closed to automobile traffic in 1967, the court was enlarged in 1981, when the 800 block of Park Avenue was also closed to traffic. In the late 1990s, the pavement was replaced with cement and bricks and a large black-and-gold compass created a focal point on the Monroe Park Campus. (Image courtesy of Ken Hopson.)

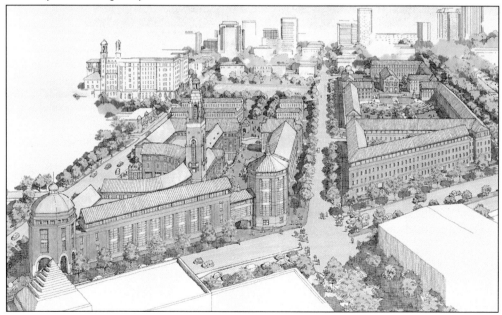

MONROE PARK CAMPUS ADDITION, 2004. This rendering by architect Eddie Smith shows the 11-acre Monroe Park Campus Addition east of Belvidere Street between Main and Canal Streets. It includes new facilities for the Schools of Business and Engineering and the renovation of the historic Central Belting Building for the VCU Adcenter. At $228 million, it is the largest capital project in the history of the university. Groundbreaking took place in November 2005.

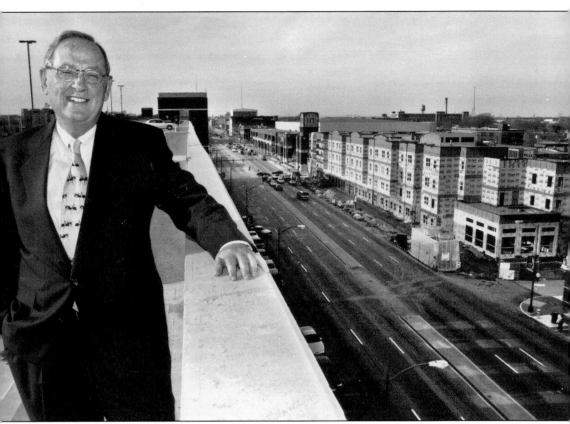

PRESIDENT TRANI AND WEST BROAD STREET, 2001. Fifteen years after Trani became president of VCU, the largely abandoned storefronts and warehouses that cluttered the 700–1300 blocks of West Broad Street had given way to new, bustling, high-tech brick dormitories, sports and sports medicine facilities, parking garages, and art studios. During this redevelopment, a 2004 fire consumed a privately built student residence hall under construction and did significant damage to several homes and businesses in Carver. VCU's expansion spurred the private conversion of old manufacturing and wholesale buildings into chic apartments and the construction of new retail and grocery stores for the first time since suburbanization began almost 50 years ago. As President Trani has stated, a "major research university is an essential building block for a modern community in the technological world." With enrollment approaching 30,000 students and the construction of the Monroe Park Campus Addition and a new critical care hospital underway, VCU continues its 168-year history of expanding to serve the needs of Richmond, Virginia, and the global research community. (Copyright *Richmond Times-Dispatch*, used with permission.)